POSTCARD HISTORY SERIES

Columbus

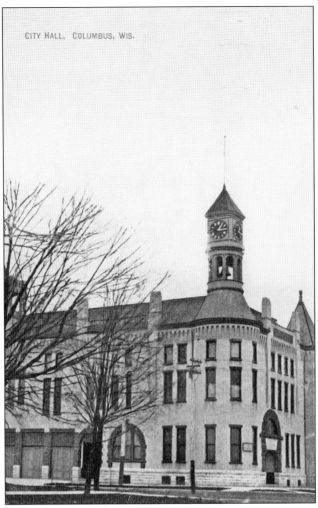

CITY HALL, COLUMBUS, WIS.

City hall is the most recognizable building in Columbus. It was built in 1892 in the Richardson Romanesque style of Watertown cream-colored brick on a rock-faced Waukesha stone foundation. To contrast with the light brick, the arched entrances, lintels, and windowsills were constructed of Doylestown-quarried sandstone. Three doors on the James Street side provided access to firefighting equipment that was stored on the ground level. The iconic clock tower is the city's most famous symbol. The four-faced pyramidal tower holds a four-faced lighted clock known as "Old Chris." Both the clock and the 1,500-pound bell beneath it were donated by Catherine Chadbourn. (Courtesy of Columbus Historic Landmarks and Preservation Commission.)

ON THE FRONT COVER: One of the most photographed scenes of downtown Columbus is from the middle of the four corners looking west on James Street. With the exception of the First National Bank Building (light structure on the right), many of these buildings date to the 1860s and are still in place today. A glimpse of city hall with its clock tower is visible at center. (Courtesy of Columbus Historic Landmarks and Preservation Commission.)

ON THE BACK COVER: Columbus Canning Company was founded in 1900 on the Crawfish River and grew to be the largest pea cannery in the world. (Courtesy of Columbus Historic Landmarks and Preservation Commission.)

POSTCARD HISTORY SERIES

Columbus

Janice R. Ulrich

ARCADIA
PUBLISHING

Copyright © 2019 by Janice R. Ulrich
ISBN 978-1-4671-0260-5

Published by Arcadia Publishing
Charleston, South Carolina

Printed in the United States of America

Library of Congress Control Number: 2018958883

For all general information contact Arcadia Publishing at:
Telephone 843-853-2070
Fax 843-853-0044
E-mail sales@arcadiapublishing.com
For customer service and orders:
Toll-Free 1-888-313-2665

Visit us on the Internet at www.arcadiapublishing.com

CONTENTS

ACKNOWLEDGMENTS

This book is only possible because of historically minded individuals who preceded me. I am grateful to Frederick A. Stare, his daughter Susan Stare, and Arnold Weihert. All three were instrumental in ensuring that Columbus's historical elements would be maintained after their lifetimes. They enjoyed preserving Columbus's history and, most importantly, documenting what they observed. I'd like to thank the following individuals who shared their postcard collections with me: Suzanne Walcott of Walcott Studio, John and Darlene Marks, Alice Schmidt, Harold Schaefer, Rod Melotte, and Dan Amato. Most of the images used in this book came from the files of the Columbus Historic Landmarks and Preservation Commission (CHLPC), and thus, many of the donors are unknown. But it is known that several postcards included here came from the collection donated to CHLPC by Clarence "Pat" and Charlotte Lange. Thank you, posthumously. A few are photographs by a former Columbus resident, Dennis Teichow, who had the images made into postcards. I'd also like to acknowledge four people who helped me with research issues: Alice Schmidt, Lois Berg Ladwig, Gloria Obermeyer, and Lori Bessler of the Wisconsin State Historical Society. Information about the relationship between photographers C.P. Ziegler and J.L. Trapp was provided in a phone conversation with Lucetta Trapp Hall and from the family history she wrote, *The Trapp Family History, 1979*, available at the Columbus Library. And thanks to several people along the journey who lent interesting tidbits of information when I shared a particular postcard with them. It has indeed been a rewarding experience to research the history behind these images and to share what I have learned.

Unless otherwise noted, all images appear courtesy of the Columbus Historic Landmarks and Preservation Commission.

INTRODUCTION

The history of the development of Columbus from its earliest settlers in 1839 through 2017 has been chronicled in two books by this author, Images of America: *Columbus* (2016) and *Discover Columbus: World War II Era to 2017* (coauthored with Suzanne Walcott). This book expands on the city's history as told through the images on postcards and one example of a postal card (Kurth Brewery). A postal card is issued by the postal authority of a country and has the amount of postage printed on it, whereas a postcard is privately manufactured and requires the postage to be affixed by the sender. Early postcards were alternatively called "correspondence cards," "mail cards," "souvenir cards," or "mailing cards."

Postcards have been a popular and less expensive way to communicate since 1861, when Congress passed the act that established the rules for mailing cards and determined the price and size guidelines. The world's first postcard, however, was sent in Austria. By 1872, the US government was manufacturing 1¢ postal cards. The term "postcard," for most of us today, conjures an image of a picture on the front of the card and space on the back for a message as well as half of the back for the address. Such was not always the case, as will be illustrated within this book. From 1901 to 1907, the entire back of the card was used for the address only. Messages were written in the margins around the picture on the front. In 1907, Congress changed the rules, dividing the back of the card to allow half of the space for correspondence, with the recipient's address on the other half. Picture postcards as we know them took off in popularity after the 1893 World's Columbian Exposition in Chicago. Many private companies jumped on the bandwagon to print postcards with a variety of subject matter, some printing serious images such as buildings and monuments while others chose to print frivolous and artistic images not based on real scenery. The Smithsonian Institution's website refers to 1907–1915 as the "Golden Age of Postcards," noting that many postcards during that period were printed in Germany. In 1915, Congress imposed a tariff on German imports, and the popularity of postcards quickly waned as the worldwide political scene changed prior to the breakout of World War I. The majority of the postcards included in this volume are from the first 15 years of the 20th century.

Many of the postcards with scenes of Columbus were taken by two photographers, J.L. Trapp and C.P. Ziegler, who were brothers in law. Carl P. Ziegler (1873–1935) was married to Anna Trapp, sister of Joseph L. Trapp (1879–1980). Longtime Columbus residents will remember when Louis Trapp drove his Minneapolis-Moline steam engine in the Fourth of July parade. Joseph and Anna were his brother and sister, all coming from a family with 15 children. Joseph Trapp had his own band, called Trapp's Novelty Orchestra. In 1905, he constructed a two-story building in the downtown business district, lived upstairs with his wife and family, and sold pianos at the

street level along with his photography business. In addition to his photography studio in his large home at 215 South Ludington Street, Ziegler also sold sheet music. His business operated prior to 1900 and lasted into the 1930s. Interestingly, most of the postcards that are photographs by C.P. Ziegler acknowledge that they were printed in Germany, whereas the photographs by J.L. Trapp do not state their source of publication.

Two additional, unusual styles of postcards were found showing downtown Columbus scenes, but their ability to be reproduced was questionable. These were leather postcards, which are a little narrower than standard postcards, and a 4.5-inch-by-27-inch panoramic view of Columbus storefronts sold as a mailing card.

As illustrated herein, many different buildings, people, and scenes became the subject matter for postcards, along with whimsical material. Several postcards of well-dressed individuals posing in full front view were found. These were likely high school graduation photographs to be exchanged with friends in the early 1900s. Two of these are included here, featuring people who were well known around Columbus over the next approximately 80 years. Several postcards were found with the caption "Columbus, Wisconsin, Scenes on an Auto Trip." Since these were all glorified and unrealistic images, they were not included.

Upon close inspection, it can be determined that there are actually several styles of postcards, although to the untrained eye, the differences may be very subtle. Actual photographs appear on historic postcards in black-and-white, sepia, or brown tones. Most current photographic postcards are in color. In the early 1900s, for marketing purposes, the images were often lightly enhanced—sometimes even greatly enhanced—with additions of color in strategic spots or even images of people added to the photograph.

Some of the postcards included here have appeared in earlier books because they relate an interesting aspect of Columbus history. But many were discovered that have probably not been viewed for more than 50 years, tucked away in the files in city hall. Specifically, greater insight into the operation of the canning factory in Columbus between 1900 and 1977 will be found herein. Previously unpublished photographs of the Badger automobile, which was manufactured in Columbus briefly between 1909 and 1911, are also included. One example of a postal card from the Kurth Brewery is included dating to 1898. Surviving members of the Kurth family were surprised to learn that orders for beer deliveries came to the largest producer of beer in Columbia County via preprinted postal cards. Postcards were found of a freight train wreck that happened in Columbus in 1922; those pictures were never published in the local newspaper, but they are included here.

With a large supply of postcards to peruse, a wide variety of historical subjects was selected from the best quality images available, bearing in mind that most of these postcards are well over 100 years old. Along with the vintage images, enjoy the contemporary views.

One

Schools, Churches, and Public Buildings

This chapter starts with several historic versions of the most notable building in Columbus, city hall. Fortunately, several versions of this beautiful building were available on postcards; it was a popular subject during the early 1900s, with the building having just been completed in 1892. Also, many postcards were available showing the two buildings that became the Columbus hospital in 1907. The images that best related the chronology of the establishment of the hospital by local residents were chosen. Beginning in 1913, the institution was operated by the Sisters of Divine Savior and called St. Mary's Hospital. Columbus's Carnegie library is also included in this chapter. Several pages are devoted to the public school system, emphasizing the building that was commonly known as Dickason School, which served to educate students from kindergarten through high school graduation during its lifetime. It too was a popular subject for postcards. The local post office is covered, along with early versions of all the churches that were in town in the early 1900s in no particular order. Prior to 1900, there had been active Baptist and Universalist congregations in town, but no postcards of their buildings were found. Images of the teachers' school, which went by many names but was commonly called "County Normal," round out this chapter.

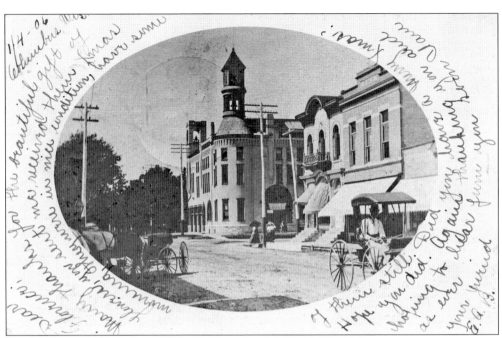

Although many postcards were available showing city hall, this one is included because it features the building within the context of the main downtown business district. This card was sent in 1906, when the whole back of the card was used for the address. The oval framing of the subject is attractive but left precious little space for message writing.

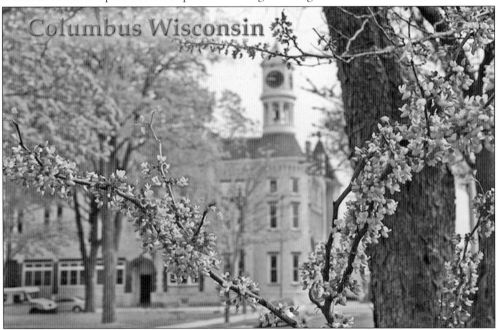

Through the branches of the redbud trees that bloom in May, the iconic 1892 city hall and its clock tower can be seen. Local photographer Rod Melotte captured this unique close-up of the blossoms flanking city hall. Since 1964, Columbus has been known as the "Red Bud City," with many trees on Dickason Boulevard near city hall. (Courtesy of Rod Melotte.)

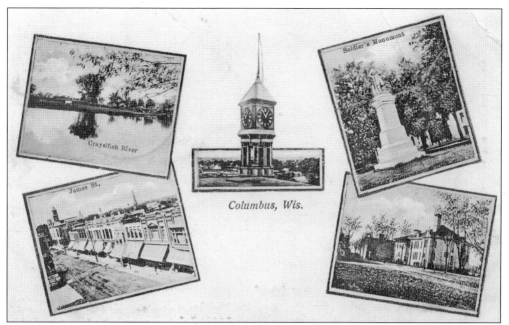

Columbus, Wis.

This postcard was made in New York and printed in Germany. Sent in 1910, it features five familiar scenes of Columbus. The iconic city hall clock tower is at center. Clockwise from upper left are the Crawfish River, the Soldier's Monument, the three buildings of the public school system after 1881, and a downtown block of West James Street.

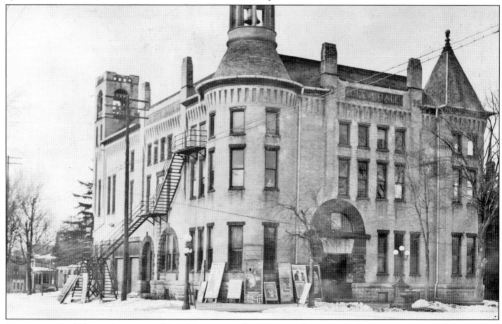

Since city hall is such a special building, another view of it is included here, but unfortunately a portion of the clock tower was cut from this postcard. This view differs from the frontispiece in that the exterior iron stairs that provided an exit from the auditorium on the second floor are shown. The approximately 400-seat auditorium was the center of cultural activities and entertainment from the time city hall was built until the mid-1930s.

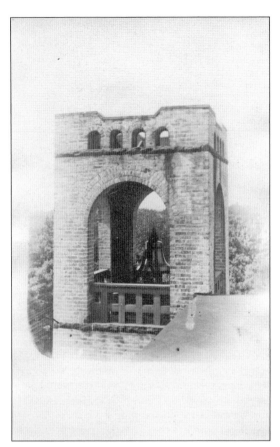

This image shows the bell tower that was erected on the southwest corner of city hall in 1892. It housed the bell to summon firefighters. Their equipment was stored on the ground level, but the hoses were hung above the stage of the auditorium to dry. When a separate fire station was built in 1946, this tower was removed from city hall, and the bell was moved for display outside the new station.

This contemporary postcard captures a historic scene in an avant-garde fashion. Shown is the 100-plus-patron balcony of city hall auditorium. Its graceful curves caught the photographer's eye in a different view than would be seen from the floor below or sitting in the balcony itself. Local resident Rod Melotte captures the unusual in mundane subjects, using lighting and colors to give his images a unique perspective. He is responsible for marketing this postcard.

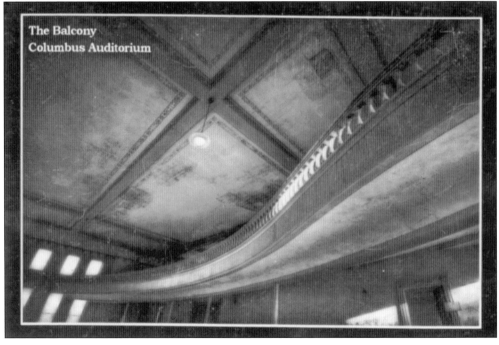

The Balcony
Columbus Auditorium

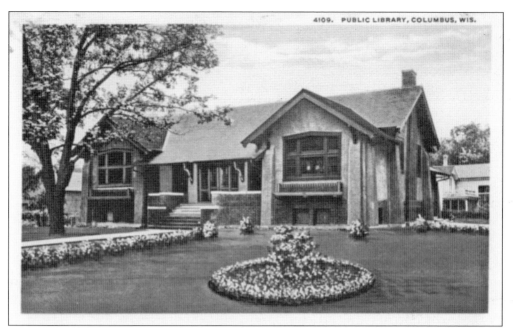

In 1912, the Columbus Public Library was built with funding provided by the Columbus Women's Club and an Andrew Carnegie grant. Located on the corner of Broadway (today Dickason Boulevard) and West James Street, it was designed by Claude and Starck of Madison, Wisconsin. The basement has served over the years as a youth center, senior center, and preschool before becoming the Phyllis Luchsinger Callahan Memorial Meeting Room and children's library. Above is the library around 1915, soon after it was built. Below, Rod Melotte provides a contemporary image of the library decorated for Christmas. Remodeling has changed the main entry to the James Street side of the building. (Below, courtesy of Rod Melotte.)

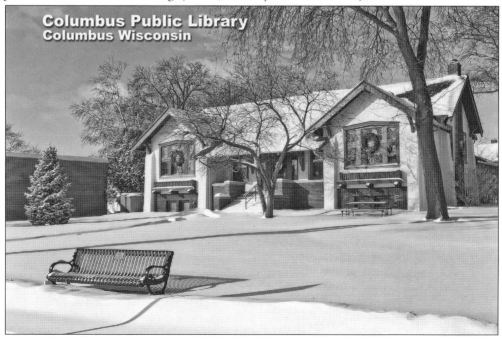

Columbus Public Library
Columbus Wisconsin

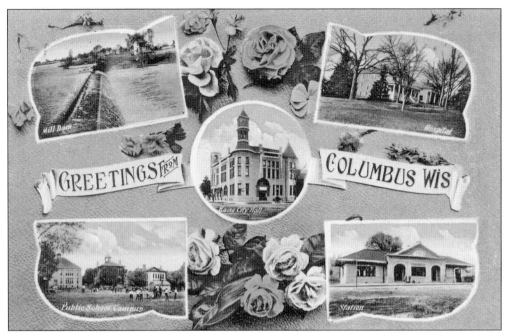

Sent in 1909, this is a rather beautiful card highlighting five historic features of Columbus. In the center is city hall. Clockwise from upper left are water spilling over the Udey Dam; the hospital at the time, located in two buildings; the railroad depot; and the original three buildings of the Columbus public school system.

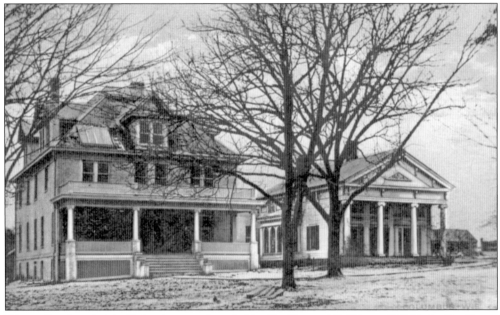

The earliest hospital in Columbus was founded by Dr. Bernard F. "Bonny" Bellack, Dr. Bryon Meacher (a Portage surgeon), and Catherine Chadbourn in 1907 on West James Street. Land was purchased from former governor James T. Lewis; the columned Greek Revival building on the right had been his home. The larger building housed 15 patients, while the smaller building provided space for ancillary services.

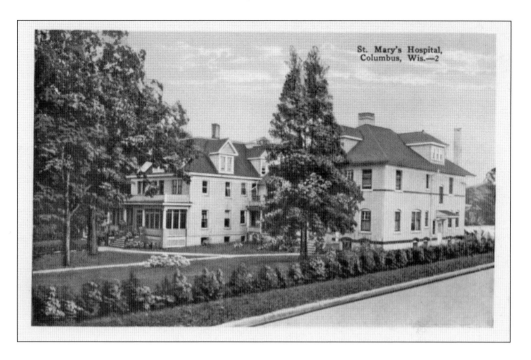

St. Mary's Hospital, Columbus, Wis.—2

Above is the 1921 building that replaced Governor Lewis's home as part of the early hospital. In 1913, the hospital became known as St. Mary's Hospital when it was purchased by the Sisters of the Divine Savior, who operated it until 1970. Below is the 1928 structure they built on West James Street replacing the large building in the previous photographs. The smaller building remained as housing for the nuns. St. Mary's Hospital had 43 patient beds, maternity facilities with 12 bassinets, a laboratory, an x-ray machine, two sun parlors, and a modern newborn incubator.

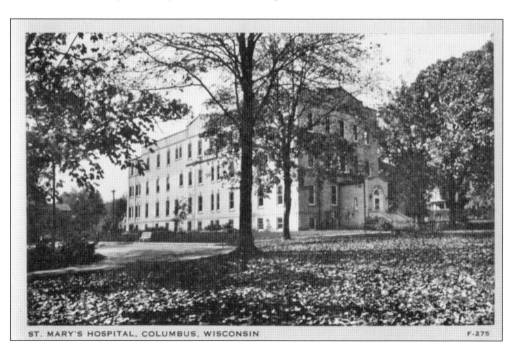

ST. MARY'S HOSPITAL, COLUMBUS, WISCONSIN F-275

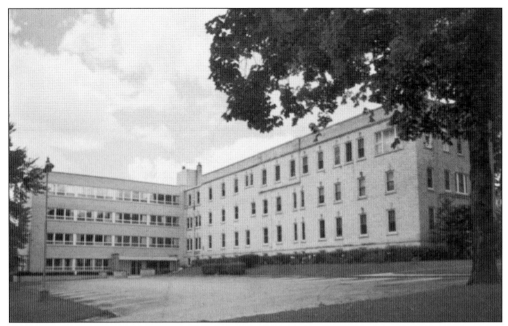

In 1959, this addition was built onto St. Mary's Hospital, bringing the number of patient beds available up to 70. In 1970, the hospital was purchased by local residents and became Columbus Community Hospital.

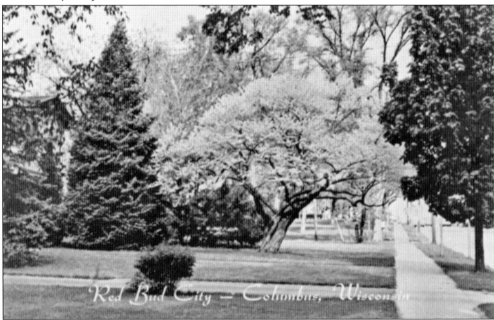

Since 1964, Columbus has been the Red Bud City. The Columbus Civic Women's Club spearheaded a campaign to plant redbuds on the four blocks of South Dickason Boulevard and to provide them for many businesses, industries, parks, and private yards around town. When the trees burst into brilliant pink flowers in May, a festival is held signaling the beginning of spring. The tree with heart-shaped leaves (*Cercis canadensis*) rarely survives north of Columbus, but many thrive here. (Courtesy of Walcott Studio.)

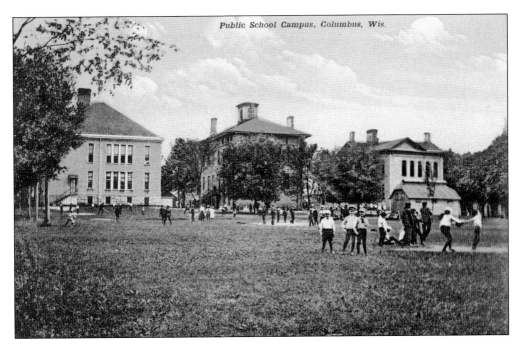

Here are the three earliest schools of the Columbus school system. The postcard above, photographed by C.P. Ziegler and printed in France, shows them from the back, or playground side. The two buildings on the right were built in 1857 for elementary students. The larger building on the left was built in 1881 to serve as the high school. Below are the same three school buildings from the Broadway (Dickason Boulevard) side, with the high school building being the most prominent in front. Notice that the Soldier's Monument is in place in front of the schools at the left edge of this postcard, sent in 1908.

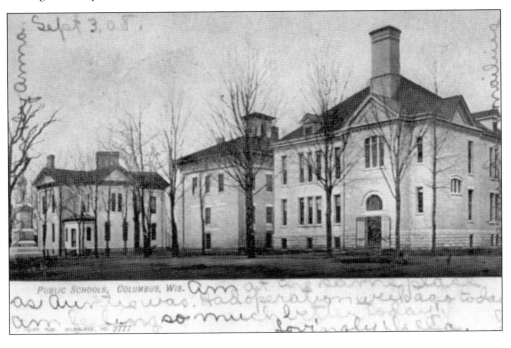

PUBLIC SCHOOLS, COLUMBUS, WIS.

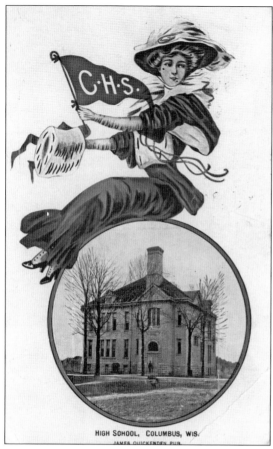

HIGH SCHOOL, COLUMBUS, WIS.
JAMES QUICKENDEN PUB.

The image at left is probably the handiwork of a traveling entrepreneur; the same artwork appears on postcards that feature the schools of other cities. Featured here is the 1881 high school building. It reads "James Quickenden, Pub." Since he was a pharmacist, it makes sense that a salesman encouraged him to sell this postcard in his business. The image below commemorates a special occasion. A large crowd has gathered for the ceremony to lay the cornerstone for the new high school, which was built in 1895 to consolidate the elementary school buildings and to expand the space for high school education all under one roof.

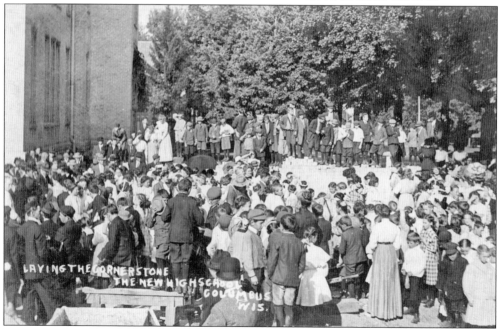

LAYING THE CORNERSTONE
THE NEW HIGH SCHOOL
COLUMBUS
WIS.

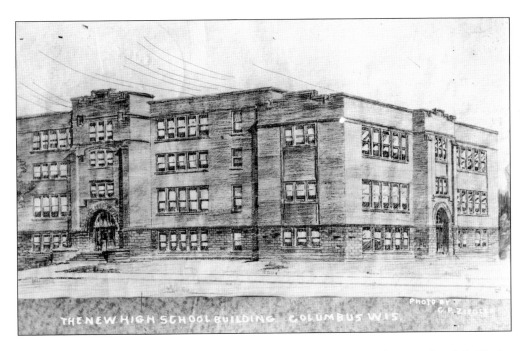

An unknown artist rendered the above sketch of the 1895 high school. Photographer C.P. Ziegler did a good job of turning the sketch into a postcard. The image below, labeled "The New High School," shows the 1895 building, which replaced the two smaller 1857 buildings. This structure consolidated the elementary and high school grades. The 1881 building remained at the corner of School Street and was used for agricultural education and as a junior high school. (Above, courtesy of Harold Schaefer.)

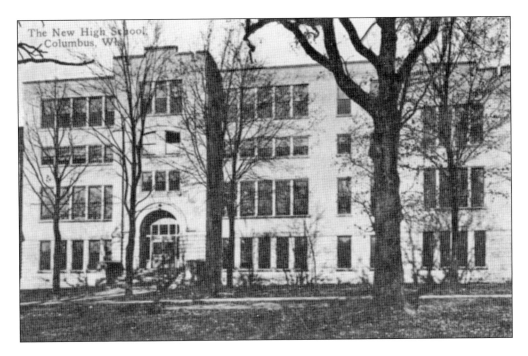

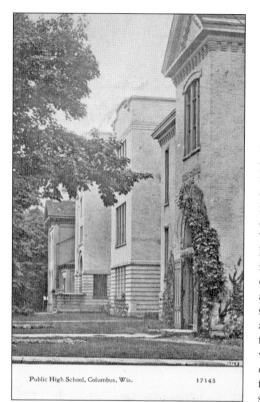

Public High School, Columbus, Wis.　　　17143

The image at left is more like a contemporary photograph than most of its period and is truly an unusual view. Here, three buildings of the Columbus school system are shown from an angle. The one in the middle was constructed in 1895 as the main building. The building on the right was the original high school from 1881. At left, caught before its demise, was one of the original 1857 elementary buildings. Below is the 1910 addition to the main building, which provided space for home economics on the ground level and two classrooms above it on the second floor. The Columbus Civic Women's Club was instrumental in advocating for home economics (domestic science) education and furnished classroom supplies. Later, the room served as a kindergarten for many years.

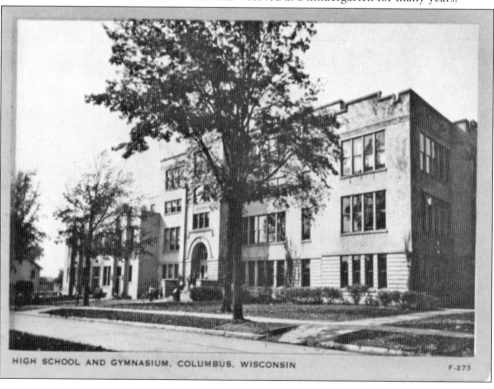

HIGH SCHOOL AND GYMNASIUM, COLUMBUS, WISCONSIN　　　F-273

Shown here is the 1935 addition to the high school building, namely the gymnasium. Over the years, this building educated children from kindergarten through high school and was referred to as the Dickason School, named after city founder Maj. Elbert Dickason.

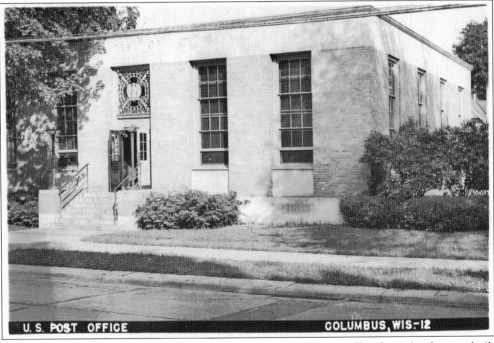

After operating out of several different downtown businesses, a post office for Columbus was built in 1939 on Dickason Boulevard at the corner of Harrison Street. Land acquisition cost $6,500, and the Art Moderne building itself cost $41,360. At the time, the state-of-the-art facility had bars on the service windows, because many money transactions occurred via the postal service.

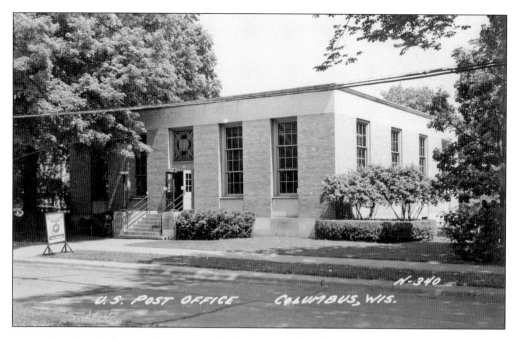

Above is a view of the post office soon after it was completed in 1939. An open house with tours for schoolchildren and adults was held as part of the dedication ceremony on May 1. Below is the back of a postcard with a large unidentified building on the front. The interesting part, however, is the stamped message, which reads, "Opening U.S. Post Office Building May 1st, 1939 — Columbus The Gem of Wisconsin — Sponsors Columbus Chamber of Commerce." These postcards were likely either sold as a fundraiser for the chamber of commerce or given as souvenirs on the day the post office opened. The US postmaster general flew in from Milwaukee to participate in the ceremony.

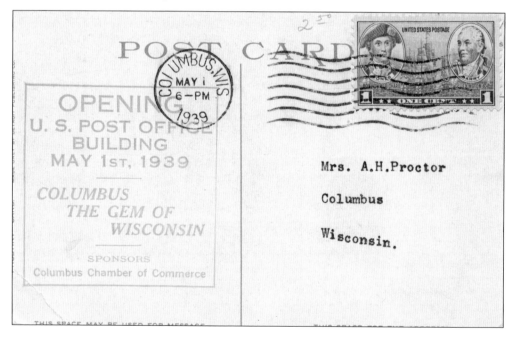

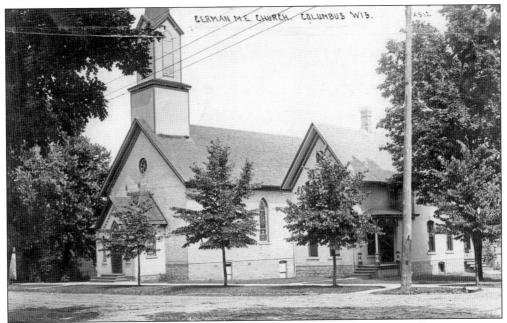

A German Methodist Episcopal congregation had been established in Columbus as early as 1852. In 1874, they built this Gothic Revival church and parsonage on North Ludington Street. In 1938, the German Methodists merged with the English Methodists, who were worshiping on Broadway (Dickason Boulevard). The steeple was removed from this church building, and it became the lodge for the Free and Accepted Masons.

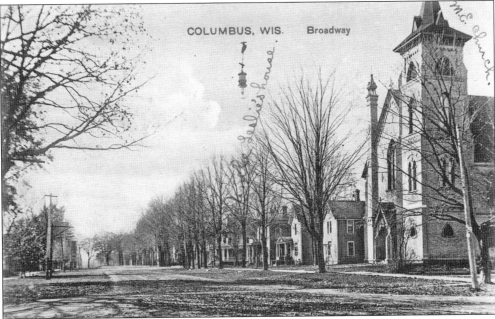

Sent in 1908, this postcard shows an interesting view of both Broadway and the Methodist church prior to street paving. This Gothic Revival building, designed by prominent Milwaukee architect Edward Townsend Mix, was erected in 1873 at 222 South Broadway (Dickason Boulevard). It featured a 160-foot steeple and $465 bell.

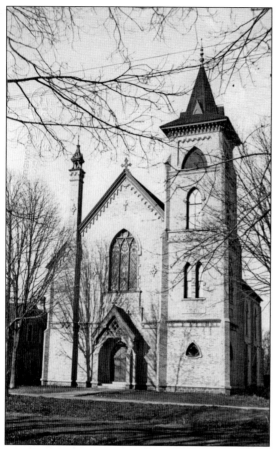

Today's United Methodist church is the result of the merger of three Methodist congregations. Shown at left is the original structure, built in 1873 on Broadway (Dickason Boulevard) by the First Methodist Society (of English speakers) as the Methodist Episcopal church. The group had been active in Columbus as early as 1847 and had built a small structure previously. The steeple of this church was destroyed by lightning around 1900 and was never replaced. The large, beautiful stained-glass rose window has remained in place despite many additions and remodels to this structure over the years. The c. 1910 image below shows a women's Bible class with their unidentified pastor in front of the church.

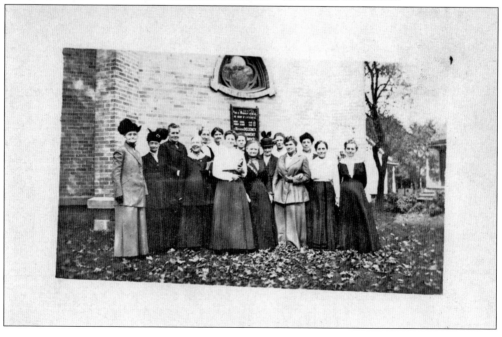

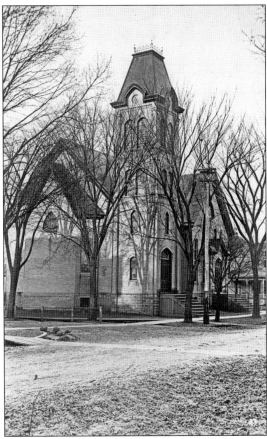

Here are two views of Olivet Congregational Church, built in 1877 at the corner of Spring and Prairie Streets, not yet paved in either picture. Milwaukee architect Henry C. Koch designed this high Victorian Gothic Revival–Second Empire structure of cream-colored brick. A notation on the image below reads "Pub. By James Quickenden." He was the pharmacist who built the Rest Haven in Fireman's Park in 1923. He was a member of this congregation, and likely sold the postcard in his pharmacy. Today, the church is called the Olivet Congregational United Church of Christ.

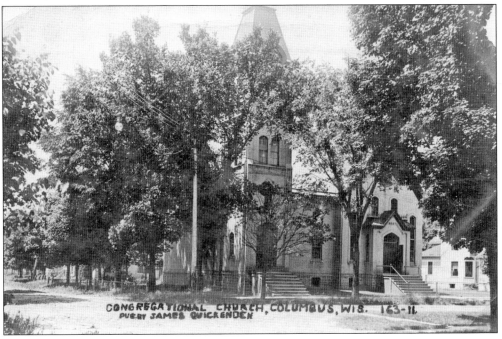

CONGREGATIONAL CHURCH, COLUMBUS, WIS. 163-11.
PUB.BY JAMES QUICKENDEN

25

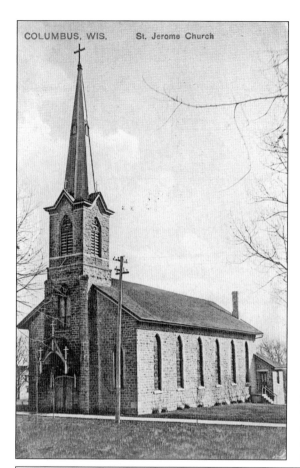

COLUMBUS, WIS. St. Jerome Church

These two views show St. Jerome's Roman Catholic Church on North Lewis Street near the railroad tracks. This building was completed in 1889, about 32 years after the cornerstone had been laid in 1857. The photograph at left was taken looking at it from the south, whereas the image below is from the north side of this structure with stained-glass windows, steeple, and a bell that cost $465. The rectory, completed in 1893 adjacent to the church, is also shown below.

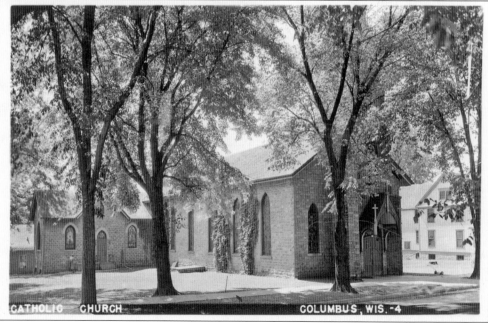

CATHOLIC CHURCH COLUMBUS, WIS. -4

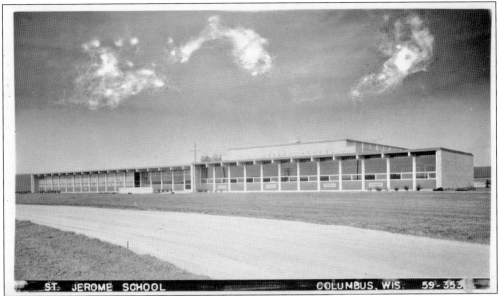

ST. JEROME SCHOOL COLUMBUS, WIS. 59-353

Although not particularly descriptive, this photograph shows St. Jerome's elementary parochial school, built in 1958 on Farnham Street. In addition to classrooms, it also contains a kitchen and gymnasium. In 1968, Fr. Ambrose Holzer came to guide the additional construction of the church on the left end of this photograph. The current church opened in 1972, with Father Holzer himself designing and making the altar, lectern, holy water fonts, oil-storage cabinets, chancel chairs, and 14 crosses for the stations of the cross. (Courtesy of Alice Schmidt.)

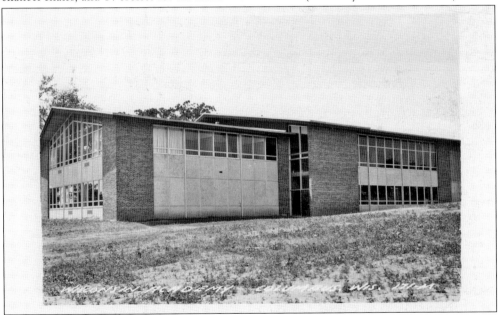

Wisconsin Academy, a coeducational private high school of the Seventh-Day Adventist Church, relocated to a campus about three miles outside of Columbus from Arpin, Wisconsin, in 1949. Currently, approximately 100 students from around the world live in dormitories on the campus. This image shows the main classroom building, which also houses the chapel, music department, and administrative offices. There is no separate church building. (Courtesy of Alice Schmidt.)

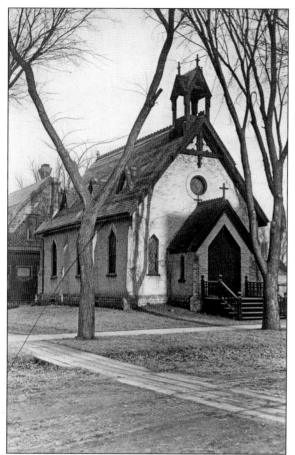

The Episcopal church was built in 1871 at the corner of Harrison and Spring Streets. It was designed by George W. Mygatt. Fr. Stanley Tarrant served the congregation for many years beginning in 1942. The congregation had quietly disbanded by 1975; the building has served as an art gallery and a residence since then.

This wooden structure was erected in 1868 as the home of the Nazareth Calvinistic Methodist Church, later to become First Presbyterian Church, established by early Welsh immigrants who settled in the Columbus area beginning in the 1840s. It is located at the corner of Mill and Spring Streets. Early on, all services were held in Welsh three times a day on Sunday, with the parishioners expected to attend all of them. Between 1938 and 1942, services were held in Welsh once a month, but since then, all services have been held in English. The building is still fondly called the "Little Welsh Church."

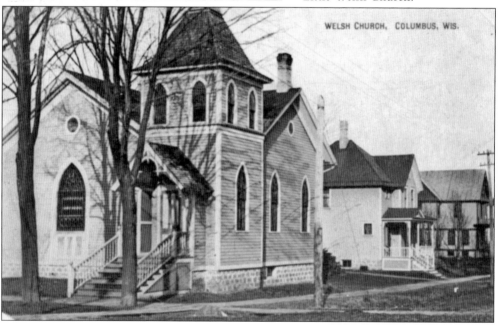

WELSH CHURCH, COLUMBUS, WIS.

Zion Lutheran Church (Wisconsin Evangelical Lutheran Synod) was founded in 1858 by the German Evangelical Lutheran Zion's Society of Columbus. In 1869, the society commenced building this church, which was completed as the edifice at right in 1879 at the corner of Mill and Spring Streets. Designed by Edward Townsend Mix, this high Victorian Gothic structure features a 125-foot lighted belfry. Below is the inside of the sanctuary in a postcard mailed in 1910. Occasional services continued to be held here in German until the 1950s. The photograph below was taken by C.P. Ziegler, and the postcard was printed in Germany.

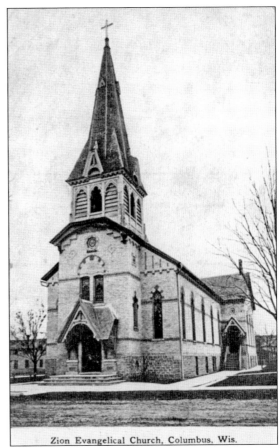

Zion Evangelical Church, Columbus, Wis.

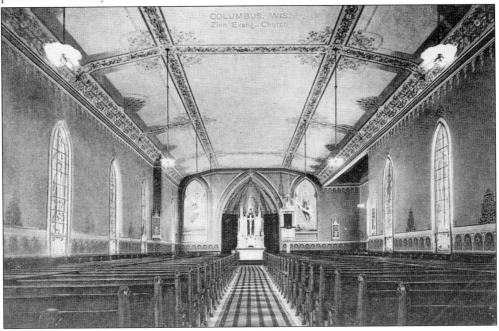

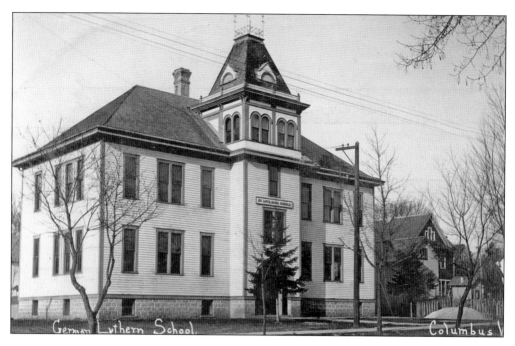

Many early residents of Columbus came from Germany and had Lutheran backgrounds. The image above shows the 1897 parochial school for grades one through eight built by the congregation of Zion Lutheran Church at 437 West Mill Street. The sign over the door reads "Ev. Luth. Zions School." It served as a school until 1955, when it was purchased by Richard Derr, who remodeled it into apartments. Below is the Zion parochial school today. Built in 1955, it now educates students in kindergarten through eighth grade and is adjacent to the church on Highway K at the west side of town. (Below, courtesy of Alice Schmidt.)

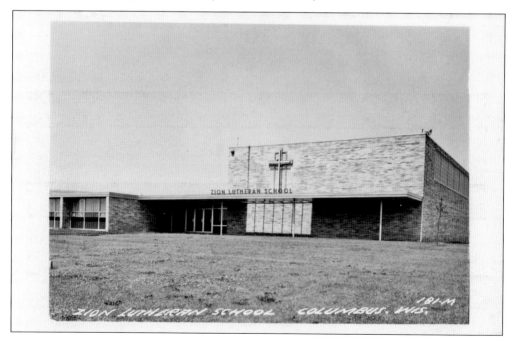

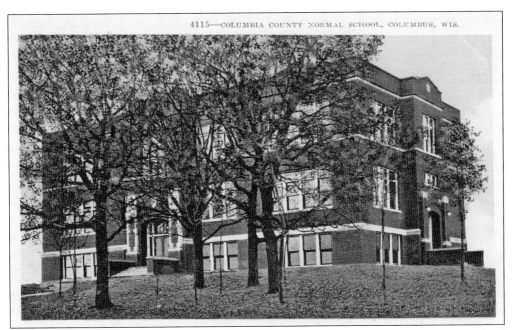

Called by several different names over the years, this training school was built in 1910 on land donated by former governor James T. Lewis on Charles Street. It provided an education for future teachers, generally in a two-year post–high school program, with students in grades one through eight attending school here and serving as live laboratory experiences for the would-be teachers. The last class of teachers graduated in 1971 from this program, called Columbia County Training School, Columbia County Normal, and Columbia County Teachers' College over the years but most often referred to as "County Normal." The view above is from the northeast corner, while below, the arbor is seen from the southeast side. Playground equipment was in the back of the building, behind the arbor.

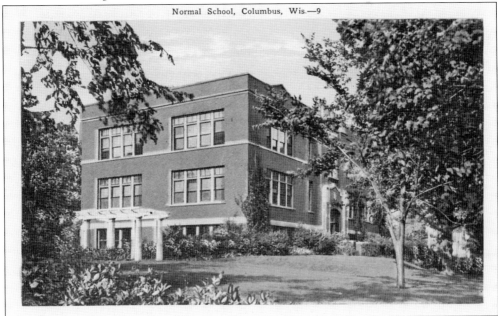

Normal School, Columbus, Wis.—9

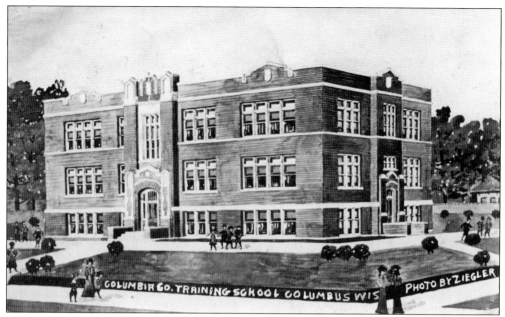

This postcard claims to feature a photograph by C.P. Ziegler of the County Normal. Given the school's elevation, this picture does not seem to be realistic. Perhaps it was made from an early conceptual drawing of the building.

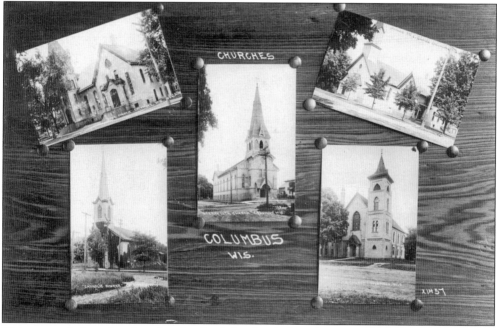

This postcard, featuring five churches in Columbus before the streets were paved, was printed in Albert Lea, Minnesota. A brief history of each church has been included in this book along with a larger picture of it. At center is Zion Evangelical Lutheran. Clockwise from upper left are Olivet Congregational, German Methodist, United Methodist, and St. Jerome's Catholic.

Two

HISTORIC HOMES AND RESIDENTIAL VIEWS

Pictures of several historic homes were found among the postcards of Columbus. It is interesting to think that in the early 1900s, people took pictures of their homes and had them made into postcards. And these were the regular homes of Columbus residents, not grandiose estates. The current versions of all these historic homes (with the exception of two that have been destroyed) are available to see in a walking tour booklet printed by Columbus Historic Landmarks and Preservation Commission, *Columbus History and Architecture Tours*. Photographs of residential streets were very common on postcards at the turn of the 20th century. A few were included in this volume simply to show what was done historically, but many of the postcards were pictures of trees with little to suggest that anything interesting was hidden behind them.

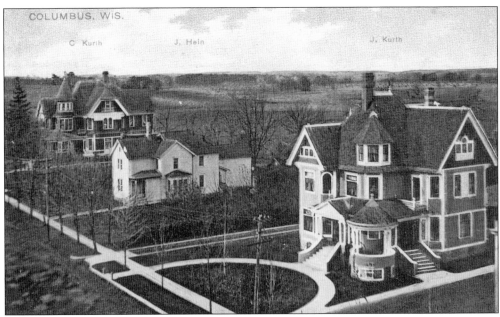

Two large mansions on Park Avenue built by the Kurth Brewery family are shown here. In front is the home of Christian Kurth, a Milwaukee malt-maker and son of brewery founder Henry John Kurth. This home, built in 1898 in the Queen Anne–free classic style, today belongs to John Robert Kurth, great-great-grandson of the brewery's founder; he uses it for rental property. The more elaborate mansion at left was built by John Henry Kurth, son of the founder, in 1897, featuring a three-story tower with a conical roof and ornamental finial. It also has a wraparound porch. Today it is a private residence.

John and Mary Swarthout built the main part of this house in the 200 block of West James Street in 1851. John was the first druggist in Columbus. The section with the Greek Revival columns is original, with the ell and porch coming later. Unfortunately, the house was destroyed in 2002.

During the days of postcard popularity, views of residential streets were often featured, though much of the picture was trees. The image above shows the as-yet unpaved Prairie Street looking west from the corner at Broadway (Dickason Boulevard). The house on the left was built by veterinarian Dr. Leslie Wright in 1902. The image below shows a better view of this Queen Anne free classic–style house. In 1929, it became the Medical Dental Building when Dr. Raymond C. Howe established his dental practice upstairs and Dr. Hugh M. Caldwell's medical practice occupied the first floor. In 1986, the house was returned to its original charm when a complementary carriage house (garage) was added. It served as the Carriage House Bed and Breakfast from 2002 to 2015. Both postcards were published by C.P. Ziegler and printed in Germany.

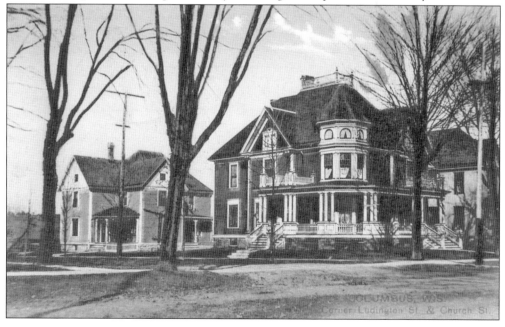

35

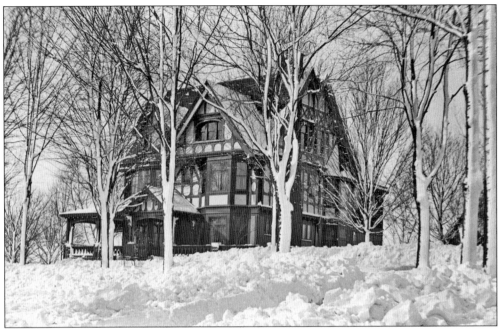

Here are two views of the largest and most elaborate of the four homes built by the Chadbourn family. This one was built in 1900 by Fredrick A. Chadbourn (1872–1947), who succeeded his father, Reuben W. Chadbourn, as president of the First National Bank when he was only 25 years old. This fine example of traditional Queen Anne–Tudor architecture was designed by Van Ryn & DeGeilleke of Milwaukee with a matching carriage house in the back. Dr. Rolf "Chub" Poser and his wife, Mary, purchased the home from the Chadbourn family in 1952, and their descendants have continued to occupy it and lovingly maintain both the exterior and the massive dark woodwork inside it.

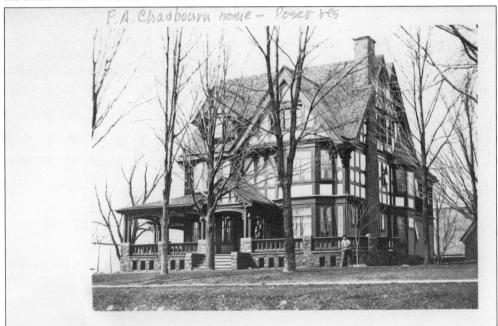

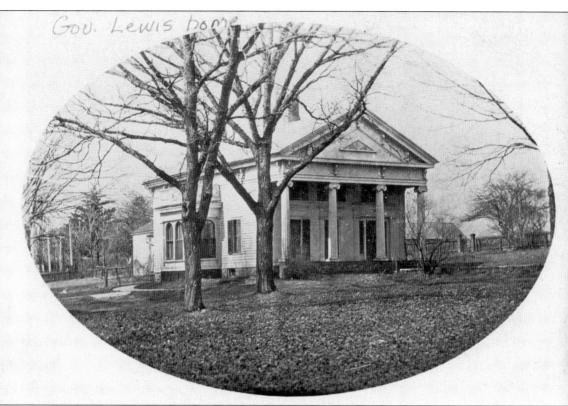

Gov. Lewis home

Columbus's most notable citizen was James T. Lewis (1819–1904), the ninth governor of the state of Wisconsin, serving from 1864 to 1866. He and his wife, Orlina, arrived in Columbus in 1845, and in 1856, they built this Greek Revival mansion on West James Street. Lewis was not only a lawyer but also an avid politician, serving as district attorney, county judge, state assemblyman, state senator, lieutenant governor, and secretary of state. Because of an active political career, Lewis spent little time in this home until he returned to live in it after the Civil War, when he refused to be nominated for a second term as governor. Lewis also built another, bigger mansion across Charles Street in 1854. This building (pictured) was one of two that became Columbus's first hospital in 1907, serving as kitchen, laundry, and nurses' quarters until it was replaced in 1920.

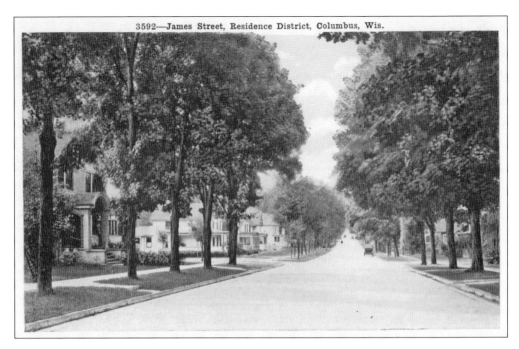

3592—James Street, Residence District, Columbus, Wis.

These two views of a residential street both feature James Street, the main east–west artery running through town. Above is a view from near the library looking west. The most prominent home near the left front was built by Guy V. Dering (1872–1932) in 1912. Built in the Prairie style, its hollow tile walls are clad in stucco. Dr. Richard Sheard established his osteopathic medicine practice in the room added at the right front in the 1930s. The view below is a bit farther west and shows more detail on the homes. The photograph was taken by C.P. Ziegler, and the card was printed in Germany.

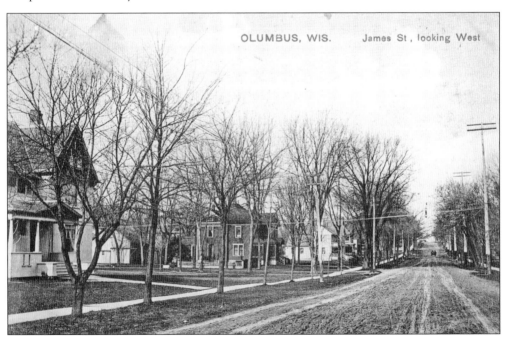

OLUMBUS, WIS. James St , looking West

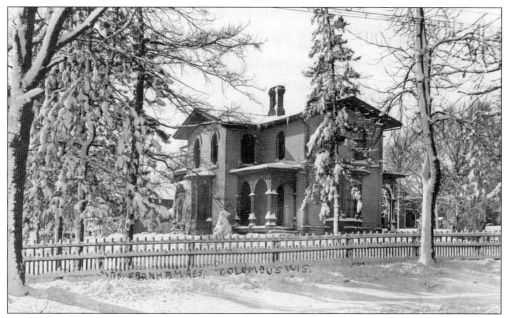

Fred F. Farrnham arrived in Columbus in 1846. He was very successful in several businesses, including grain shipping, produce, and lumber. He owned a commission store as well as a warehouse near the railroad tracks. In addition to the 1867 Italianate brick house seen here, he also erected the Farnham Block, a three-story building in the downtown business district. This home has symmetrical porches, widely overhanging eaves, and tall, narrow, round-arched windows.

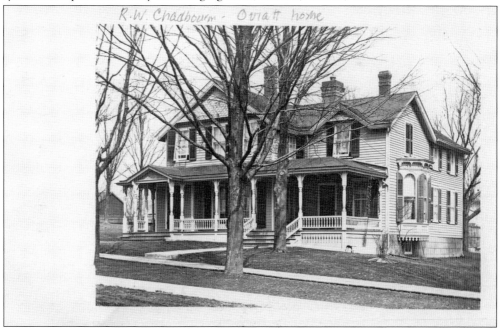

This was the home of Catherine and Reuben W. Chadbourn, founder of the First National Bank. Built in 1860, its style is called "vernacular" because of its simple, boxlike structure with a low-pitched roof. The house is at 654 West Prairie Street and has been the home of Dr. Ernest C. Oviatt (1869–1953), a dentist, and is currently occupied by Richard Derr.

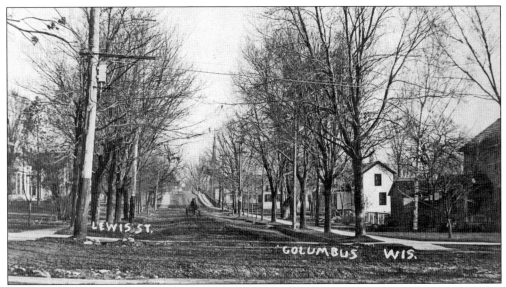

This photograph by C.P. Ziegler shows unpaved North Lewis Street from the James Street intersection with the viaduct in the center and the St. Jerome's Catholic Church steeple beside it. Barely visible on the left is a c. 1875 home commonly called the "Wheeler House" because it was long owned by John R. Wheeler, founder of Farmers & Merchants Union Bank. During the bank's construction, when architect Louis Sullivan came to town, he stayed with the Wheelers. This postcard was sent in 1907.

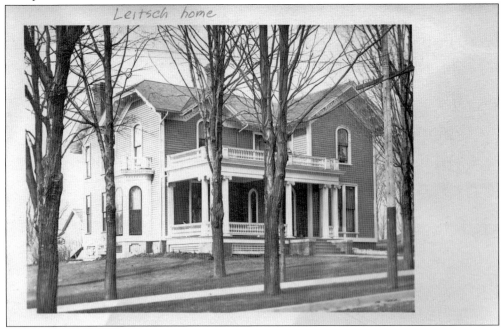

This is the home that Smith Chadbourn (1834–1891) built in 1869 at 651 West Prairie Street. The brother of Reuben W. Chadbourn, Smith followed him to Columbus to join him in the real estate and money lending businesses, subsequently building this house across the street from Reuben. William C. Leitsch (1867–1923), who was instrumental in the canning factory, once owned it. Today it is owned by Steve and Julie Hajewski.

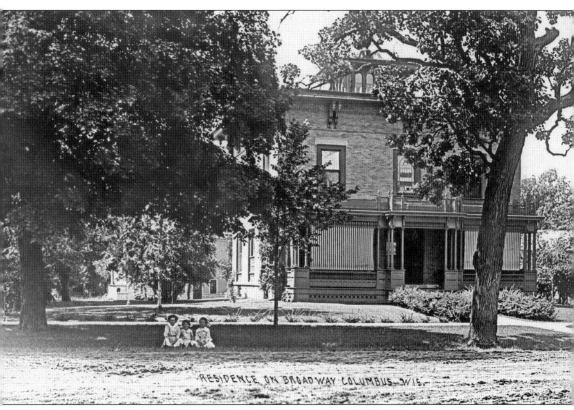

RESIDENCE ON BROADWAY COLUMBUS. WIS.

The Griswold brothers, George and William, arrived in Columbus about 1850. They were lawyers and merchants. George, who was going blind, had this house on Broadway built as a replica of his New York home. It could not be completed until 1857, when the railroad arrived in town, hauling the special pink brick he ordered from New York. This Italianate house form is called "cube and cupola." The widow's walk (or cupola), though obscured in this c. 1925 photograph, was originally topped with a large finial. In 1955, Jack Murray and Paul Zeidler remodeled this house to become their funeral home. When Murray left to pursue other business interests, Zeidler continued to operate the business until his death in 1978. Zeidler's wife, the former Rosie Schmitt, then operated the funeral home for another three decades, selling to the Koepsell family in 2011.

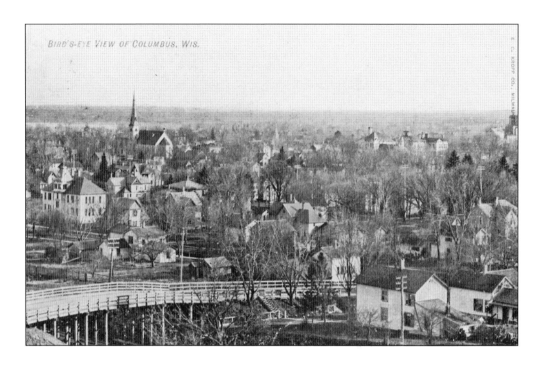

The bird's-eye view of the city above was taken near the south end of the viaduct over North Lewis Street. Zion Lutheran School and Church are recognizable. Likely near the top right is a portion of the downtown business district. This card was sent in 1908. The postcard below is labeled James Street, but with so many trees, it is hard to determine where the picture was taken. Here the unpaved street is seen as autumn approaches.

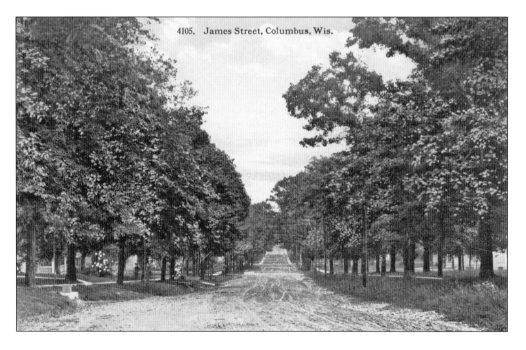

The image above shows Ludington Street looking south, but it is unknown where the photograph was taken. Notice that it is almost impossible to distinguish the tree trunks from the telephone poles. Below is a nice picture showing a paved sidewalk but as–yet unpaved street. Two homes with pillared porches are seen beside each other, likely on the west side of the 200 block of Broadway south of the Methodist church.

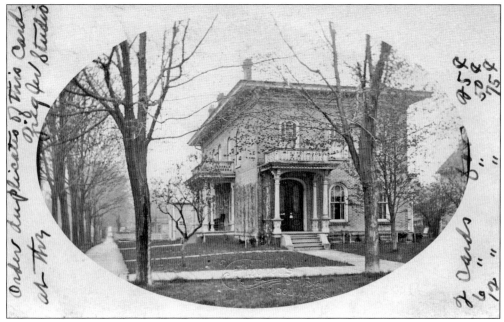

The Alonzo Henry Whitney (1816–1888) house was built in 1868 in the Italianate style of cream-colored brick. Whitney was an early settler, capitalist, business owner, and financier. The substantial house has been a funeral parlor and now is home to Walcott Studio in the wraparound addition. This photograph was taken by C.P. Ziegler, based on the writing on the front of the card.

Prairie Street Columbus Wis. Photo by Trapp

Tree-lined residential streets were a very popular subject for early postcards. Prairie Street, shown here, was home to many business owners and professional people in the early 1900s. Some beautiful, historic homes were located on Prairie Street at the turn of the 20th century, like today, but apparently J.L. Trapp preferred to photograph trees instead of homes.

Three

BUSINESSES AND
DOWNTOWN VIEWS

This chapter features stores and businesses of the downtown business district—the four blocks surrounding the four corners. Again, they are shown in random order. Postcards of the downtown business district were very popular in the early 1900s. Those chosen were the best quality available, and not redundant views. An attempt has been made to present images in a logical sequence, with often the same group of stores shown at different periods for comparison. A few postcards of Fourth of July parade entries are included when they were associated with a particular business. This chapter contains several images of the Badger automobile, which was manufactured in Columbus from 1909 to 1911. Together with the images on pages 100 and 101 in Images of America: *Columbus*, there is probably no larger collection of photographs of Columbus-manufactured Badger automobiles in print. Three pictures of Badger automobiles decked out as Fourth of July parade entries are included here, along with two previously unpublished views of the car.

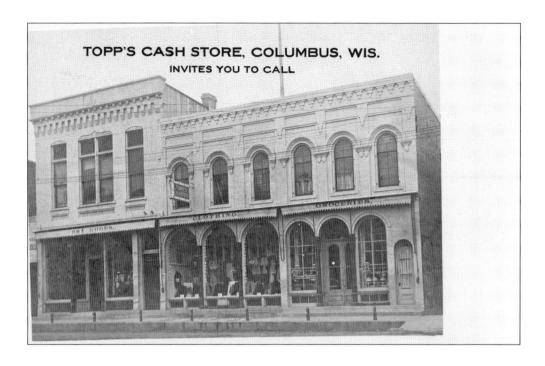

The John Topp & Bro. Company dry goods and grocery store was a staple for area shoppers for more than 75 years. Opened in 1863 by John and Charles Topp on North Ludington Street in the large store pictured above, the business continued to serve the community with the same name for another 38 years after the founders died around 1900. Their motto was "A square deal for a round dollar." Below, what appears to be a boat was the company's entry in the Fourth of July parade around 1910.

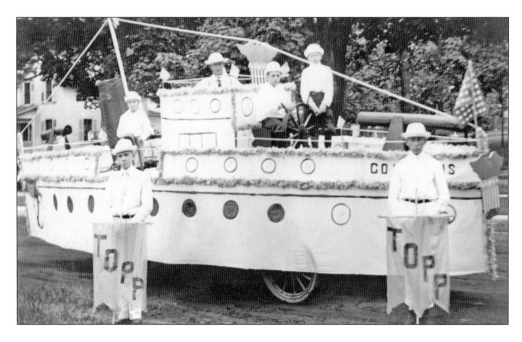

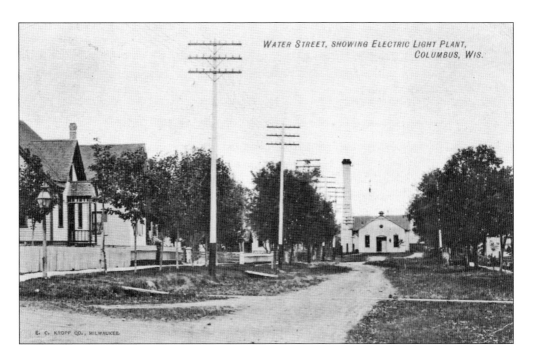

Here are two views of the water and light plant at the north end of Water Street, abutting the railroad tracks. Above is the front. Two wells were located at this plant in addition to steam engines burning coal to generate electricity for the city. Running water first became available for city residents and businesses in 1896. Electricity generation followed in 1898. The c. 1918 view below shows the side of the plant with the canning factory buildings in the background, also along the railroad tracks.

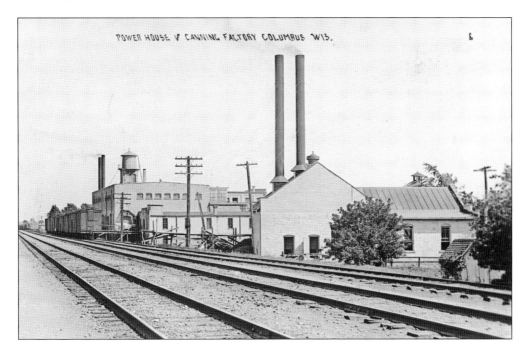

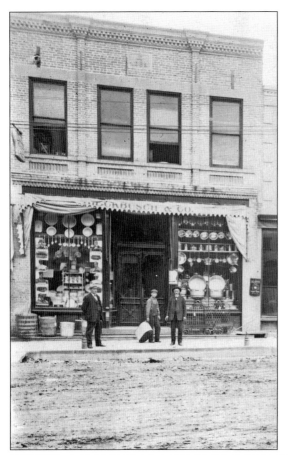

Built in 1889 by Julius Krueger as his hardware store, this building at 126 South Ludington Street was owned for a longer span by Kieckbusch & Co., as shown at left. That business thrived, selling stoves, ranges, furnaces, and other general housewares. In 1919, John Gustave Heidke bought the building for his famous sweet shop, putting in a bowling alley upstairs. In 1946, the building became a tavern and restaurant. Since 1992, it has been Dr. Craig Campbell's Capri Steak House. Below is the west side of South Ludington Street before the streets were paved, looking south. At front right is the Swarthout Building (Sharrow's today), with Lien's Garage visible at the far end of the block. Krueger's Hardware Store was in the middle of this block.

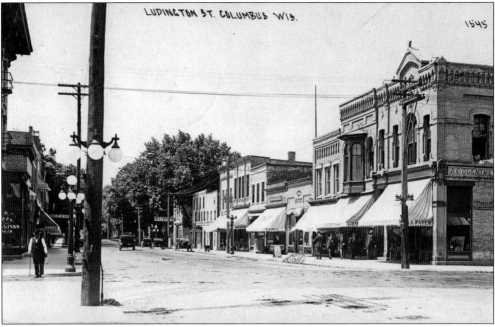

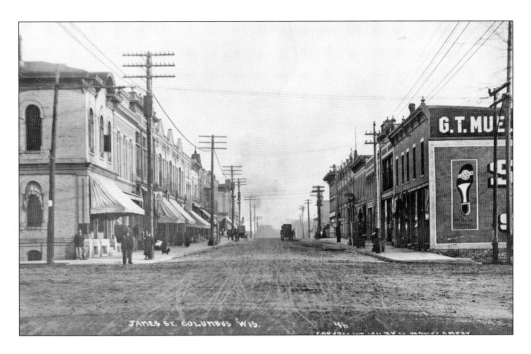

Here are two c. 1910 views of James Street before it was bricked. The building at the right front of both photographs was replaced by the Farmers & Merchants Union Bank in 1919. Both images are looking east from the intersection of Broadway (Dickason Boulevard). The sign on the corner store depicts the sole of a shoe with a label reading "SELZ." Below is a Fourth of July parade band heading west on James Street, while other units follow behind. An interesting arch-like structure welcomes parade goers to the downtown business district.

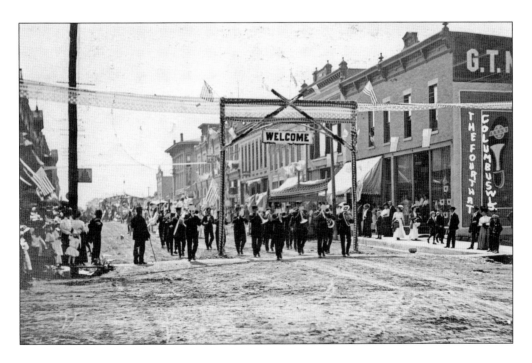

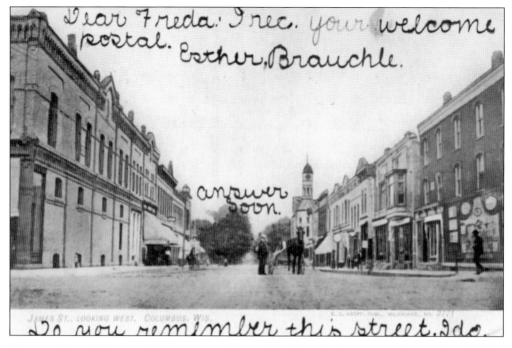

Dear Freda: I rec. your welcome postal. Esther, Brauchle.

answer soon.

JAMES ST., LOOKING WEST, COLUMBUS, WIS.

Do you remember this street. I do.

Here are views of the same downtown storefronts taken from the four corners intersection looking toward city hall on West James Street. The postcard above was sent in 1908 and addressed simply to "Miss Freda Schultz, Santa Anita, Cal." Although the street looks shiny, it was not yet paved. The c. 1925 image below shows the same street with the large, light gray First National Bank building of 1916 having replaced two former Italianate buildings. In both views, the Swarthout Building is at front left, while the Corner Drug Store is at front right. The H.C. Lange Restaurant was at the far end of this block on the left side.

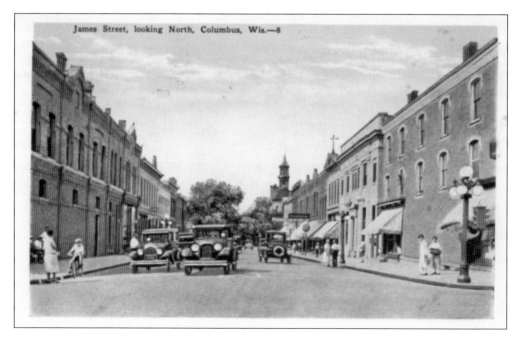

James Street, looking North, Columbus, Wis.—8

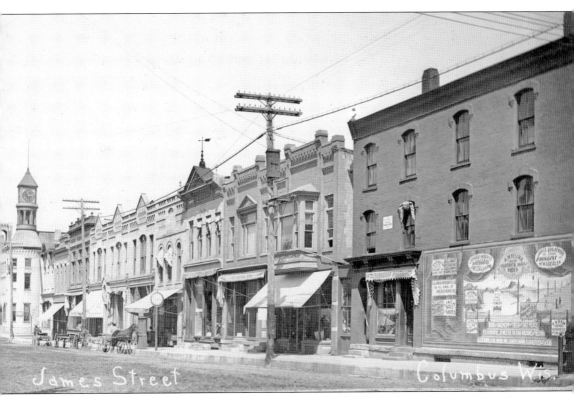

This photograph, taken by J.L. Trapp, shows only the north side of West James Street at about the same time as the upper image on the preceding page. First National Bank appears on the second awning from the corner store. What makes this image so interesting are the advertisements of other businesses on the wall of the Corner Drug Store, here identified as Woltersdorf Pharmacy on its awning. The ads read: Jones & Roberts, Druggists, Jewelers, and Optometrists; Columbus Mercantile for all kinds of Merchandise; North West Edge Hotel, $1 a day, as good as it gets; H.C. Lange Restaurant, Toys, Fruit; Bonnett Millinery, low prices; Linck Bros. Shoes; James Quickenden, Druggist and Newsdealer; A.M. Bellack, Tailor, Clothier, Hats, Shoes; C.P. Ziegler, Photographer; F. Voth, Harnesses and Collars; and Good things to eat, Fowler's. Other signs are unreadable. The three parallel bars at the bottom of this sign are filled with more names of advertisers and their products.

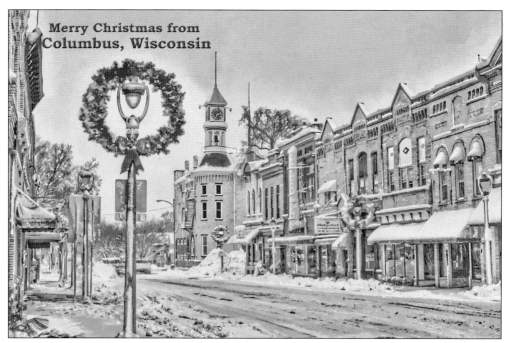

Here is the same downtown block shown on the preceding page in a contemporary photograph by Rod Melotte. Rarely today are postcards used as Christmas cards, but this one was. Melotte often uses unconventional colors; this image has a green cast. (Courtesy of Rod Melotte.)

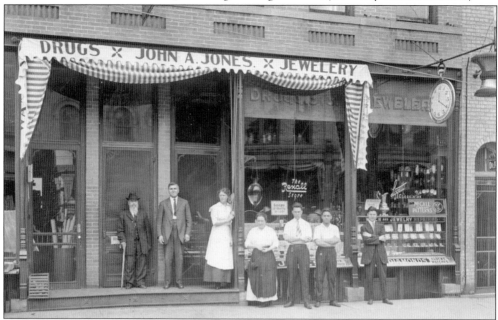

John A. Jones started his "jewelery" store in 1893 on West James Street. Jones, who also performed optometric examinations, is shown here second from left around 1915. Note the awning, the Rexall sign in the window, and the mortar and pestle suspended above the window at right. Jones also sold drugs and, stranger yet, McCall's sewing patterns for 10 or 15¢ each. As expected, the store repaired and sold watches and clocks in addition to diamonds, silverware, and china.

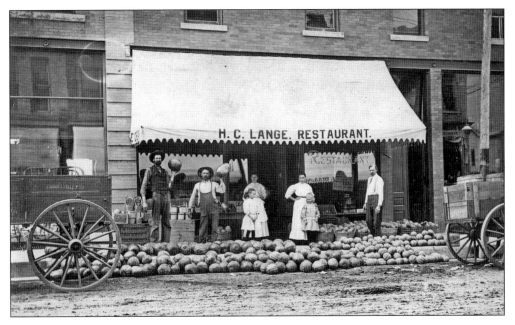

Herman C. Lange (1868–1935) operated his combination restaurant and grocery store on the south side of West James Street beginning in 1907. Thanks to his daughter Myra Lange, there are several pictures of his business in the Columbus Historic Landmarks and Preservation Commission files. Two c. 1908 postcards were chosen for inclusion here. Above is Lange on the far right along with a family of customers admiring a fresh load of watermelons he just received. Below is Lange with a shipment of what are likely peaches in reed baskets that he recently unloaded. A window sign advertises Iroquois 5-cent cigars. When Lange retired, his brother-in-law Edward "Eddie" Groening bought the business and installed a soda fountain.

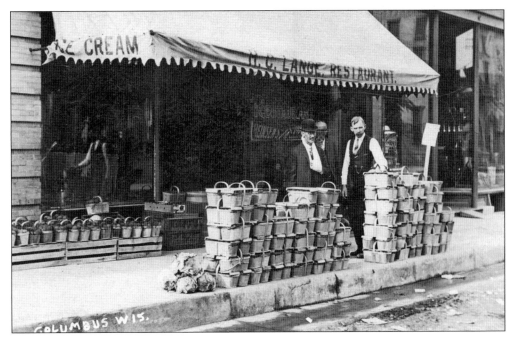

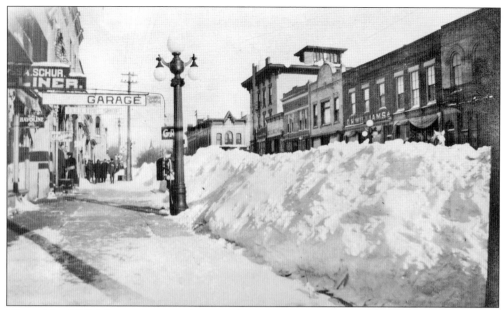

Files of the CHLPC contain several postcard views of a large snowstorm that hit Columbus in 1918. Interestingly, however, no mention of the storm was found in the local newspaper, the *Columbus Democrat*. This view was from the south end of Ludington Street in front of Lien's Garage, whose gasoline pump is partially visible behind the streetlight.

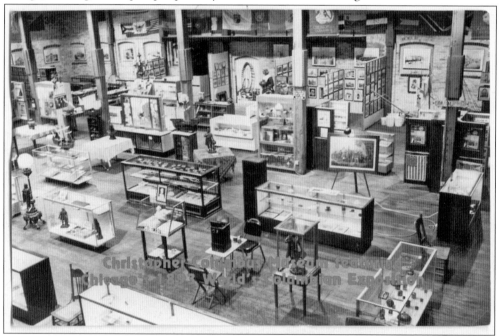

Here is an overhead view of the exhibits in the Christopher Columbus Museum within the Columbus Antique Mall, owned by Dan and Rose Amato. This exhibit features over 2,000 souvenirs and memorabilia from the 1893 World's Columbian Exposition in Chicago. The Columbus Antique Mall is the largest antique mall in Wisconsin and is located in the buildings of the former canning factory. (Courtesy of Dan Amato.)

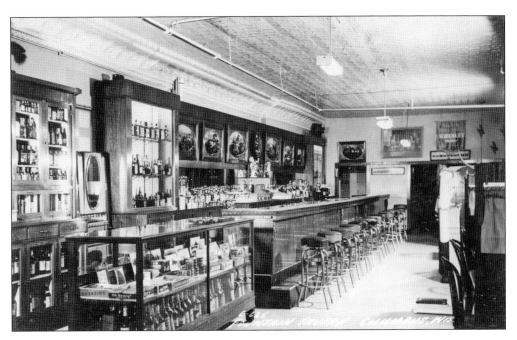

"Seagan" Lange's Fountain Tavern, at 139 North Ludington Street, was an opulent gathering spot, as shown above. The tavern had burned out around 1930, and when restored looked like this, with its pressed tin ceiling. Frank "Seaganbuck" (a German nickname later shortened to "Seagan") Lange (1883–1945) was a pitcher for the Chicago White Sox around 1910. After his death, his wife, Emma, continued to operate the business, which in later years was owned by LeRoy Hoene as Hard Head's Tap. John Hein Jr. was also owner at one time. The image below shows the jukebox on the right with four bartenders. The back bar was especially beautiful. There were seven curved, beveled-glass chambers that held birds stuffed by a taxidermist.

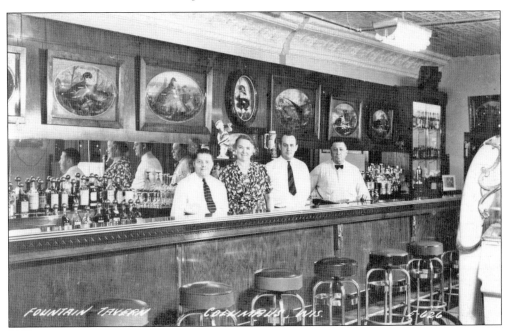

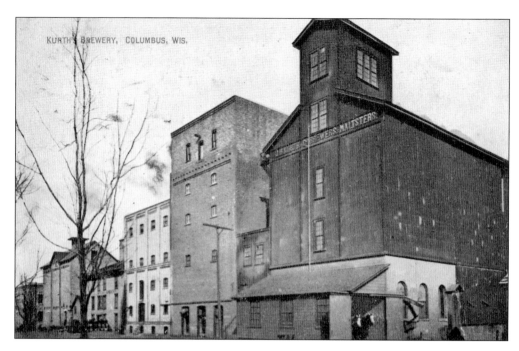

Kurth Brewery was founded in 1859 by German immigrant Henry John Kurth and his wife, Frederika, on Madison Street (Park Avenue). By 1914, it was the largest brewery in Columbia County. The operation included multiple grain elevators, a malt house, a five-story brewery, a beer cellar, a barn for wagons and horses, an icehouse, a bottling factory, an electric dynamo, a cooperage (barrel-making facility), three warehouses in Wisconsin, three saloons in Columbus, and 17 other saloons in south central Wisconsin. Here are two slightly different views of the Kurth complex.

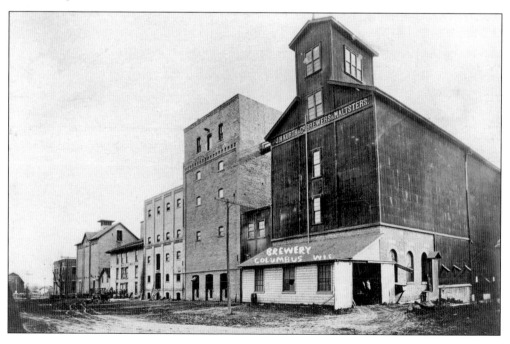

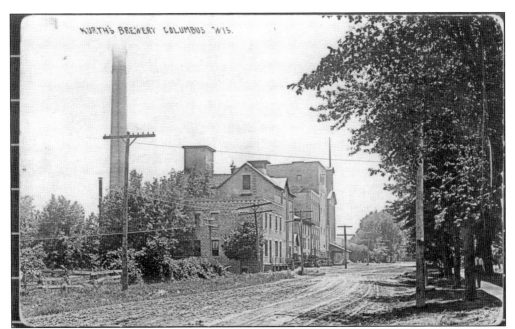

The above image shows the Kurth Brewery complex and smokestack from the north before the 1903 office and hospitality building was added. Everything changed for the brewery on July 20, 1916, when a devastating fire struck, destroying all the buildings except the office. At right are some of the remains, so badly damaged that production ceased. Prohibition in 1919 dealt another blow. The brewery survived by making soda pop until Prohibition ended in 1933, at which time it resumed beer production on a limited scale. (Right, courtesy of Harold Schaefer.)

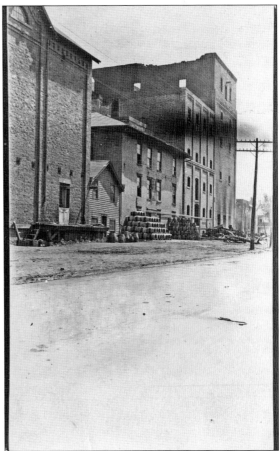

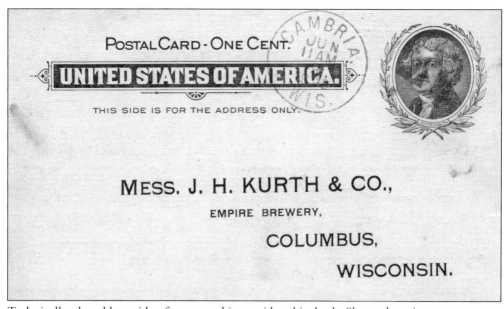

POSTAL CARD - ONE CENT.

UNITED STATES OF AMERICA.

THIS SIDE IS FOR THE ADDRESS ONLY.

MESS. J. H. KURTH & CO.,

EMPIRE BREWERY,

COLUMBUS,

WISCONSIN.

Technically, the address side of a postcard is considered its back. Shown here is a government-issued postal card that Kurth Brewery used for receiving orders. In the address, "MESS." is an abbreviation for messieurs, the plural form of monsieur, or mister. Although J.H. (John Henry) Kurth was named in the address, the sender wished to communicate with all the men of the company, then known as the Empire Brewery.

Cambria June 9th 1898

MESS. J. H. KURTH & CO.:

Gentlemen—Please forward by freight,

......7......HALVES. 4 Bock......CASES QUARTS.

......1......QUARTERS. " PINTS.

......2......EIGHTHS.

......H. Martin......

To simplify placing orders, the Kurth Brewery (then Empire Brewery) provided uniform postal cards to its patrons. This example was sent in June 1898 for delivery to H. Martin in nearby Cambria, Wisconsin. His order refers to the number of half barrels, quarter barrels, and eighth barrels of beer he wanted. Additionally, space is provided to order pints and quarts of beer by the case.

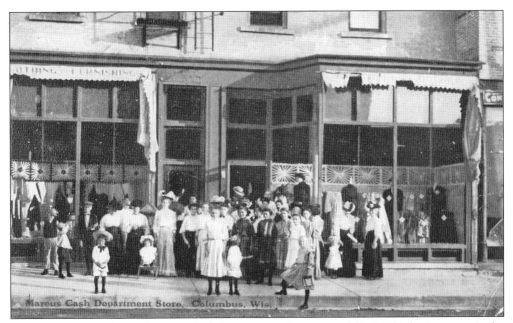

A crowd gathers in front of Marcus Cash Department Store around 1910. This business was in the large building at the southeast corner of the four corners. Although many different tenants have occupied the space, it was originally the Whitney Hotel, built by Henry Alonzo Whitney. His first hotel burned in 1857. The replacement was built in a record four weeks and has stood ever since.

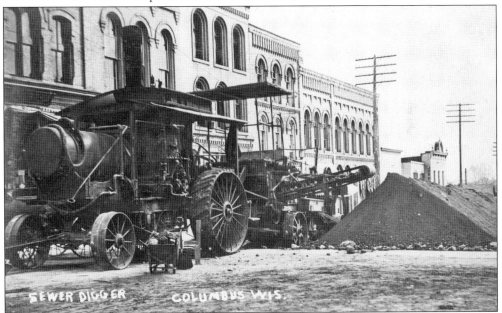

This 1912 photograph shows a steam engine digging up the as-yet unpaved downtown street to install sewer lines. The local newspaper contains many articles prior to that time in which residents voiced doubts about the virtues of sewer service, but during his one term as mayor, Dr. Edward M. Poser prevailed, and sewers were installed for the health and safety of city residents. This photograph by C.P. Ziegler was taken near the four corners, with the buildings on the north side of East James Street in the background.

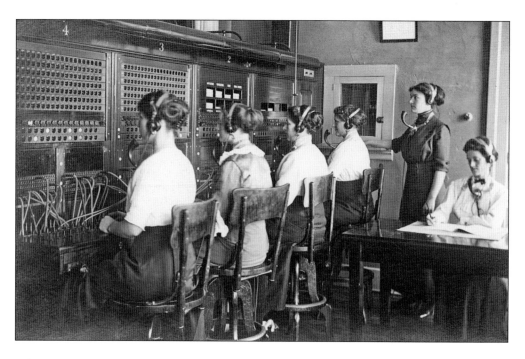

Telephones came to Columbus in 1886. The 1912 photograph above shows operators at work in the telephone building on West James Street, today the home of State Farm Insurance. From left to right are Rose Boetscher, Iva Sherman, Louise Schmidt Fetter, Ellen Ford, Maria Brandt, and Jennie Jones (chief operator). In the spirit of showing support for the community, the Wisconsin Telephone Company provided the float below for the Fourth of July parade around 1910. Likely it is the telephone company employees riding in the float. (Above, courtesy of Alice Schmidt.)

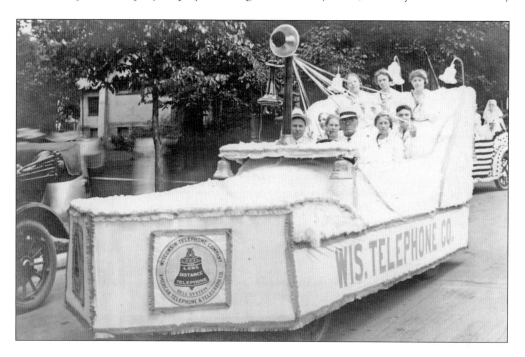

This neoclassical First National Bank building was erected in 1916 on the north side of West James Street, more than doubling the work space in its preceding building. Notice that the downtown streets are bricked at the time of this c. 1920 photograph. The First National Bank was established in 1861 by Reuben W. Chadbourn (1819–1890). Two more generations of Chadbourns went on to operate the bank.

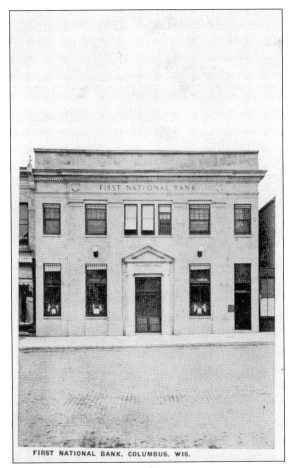

FIRST NATIONAL BANK, COLUMBUS, WIS.

The Michael Leonard Seed Company was on Birdsey Street at the railroad tracks. In 1900, this Columbus plant joined the seed company's other businesses in Iowa and Illinois. The plant here developed pea and sweet corn varieties for the burgeoning canning industry. In 1940, Leonard J. "Jack" Kaasa bought the building for his hybrid corn business. Later, the Rudy-Patrick Company used the building to distribute alfalfa and grass seeds.

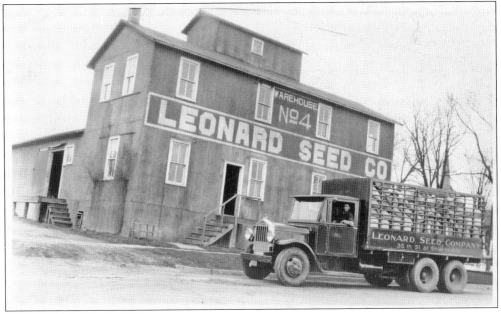

Will see you about _Soon_ .

Best Regards,

Luly & **JOHN A. DALY**

The Michael Leonard Seed Company developed many kinds of vegetable seeds over 50 years. The image at left features not only sweet corn and peas but also tomatoes, beets, spinach, and wax beans in a postcard advertisement to home gardeners to purchase directly from the seed developer. Below, the message side of this postcard sent in 1939 for 1¢ encourages customers to order their seeds from home when the company representative comes to call on them.

MICHAEL-LEONARD'S SEEDS

Insure Satisfaction

The best seeds obtainable. Carefully grown. 50 years' experience in the growing of seed insures highest quality and most value for the money.

Your dealer, whose name is on this card, carries a complete assortment of MICHAEL-LEONARD'S SEEDS and can supply you with all your SEED at all times.

PURCHASE YOUR SEEDS AT HOME. Save uncertainty, expense and trouble.

Buy at Home

MICHAEL-LEONARD SEED CO.
CHICAGO

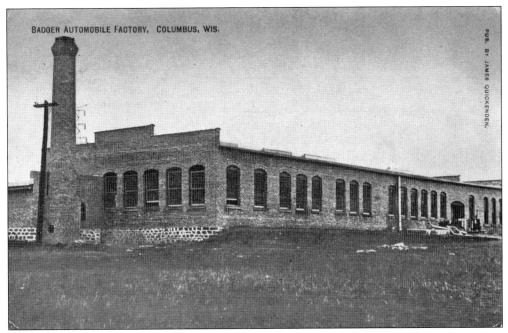

This building on Baden Street near the railroad tracks was erected in 1909 for assembling Badger automobiles. Unfortunately, that venture lasted less than three years. When the business failed, the building was sold to the Columbus Canning Company. E.W. Arbogast of nearby Watertown designed the cars and recruited Columbus business leaders to provide financial backing. Only 237 Badger automobiles were manufactured in Columbus before the company was plagued by marketing and distribution issues. The image below shows two Badger entries in the Sentinel Endurance Test on South Ludington Street in downtown Columbus around 1910. Note the Corner Drug Store in the background. (Below, courtesy of Walcott Studio.)

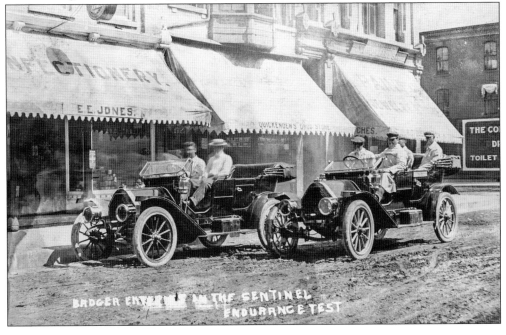

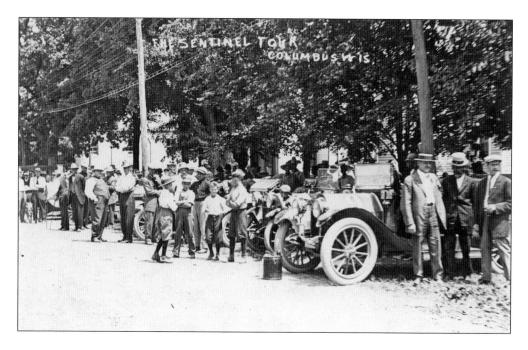

Above is the Sentinel Auto Tour around 1910 with a Badger automobile, manufactured in Columbus, competing. In order to introduce the new method of transportation that was replacing horses, competitions were held to determine which vehicles were the fastest, most comfortable, and most reliable. The endurance tests drew large crowds of potential buyers. Below is Badger No. 4 in the State Auto Run in downtown Columbus. This event featured 25 automobiles competing for a whole week, covering 808 miles in the state of Wisconsin. Both events drew large crowds of curiosity seekers. The image below was photographed by C.P. Ziegler.

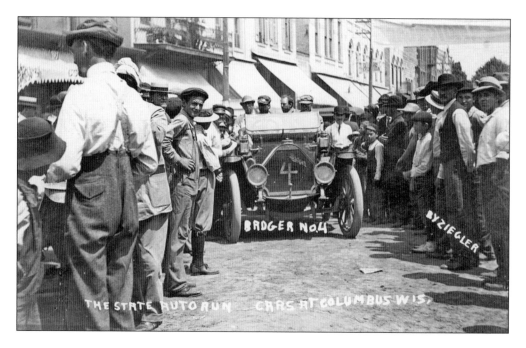

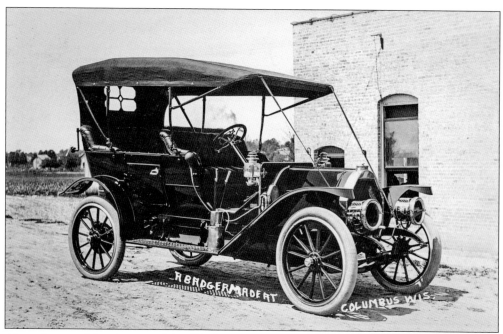

Above is one of the three models of Badger automobiles manufactured in Columbus, this one with a roof. Two models of touring cars and a two-passenger runabout were assembled in the Columbus plant. Although the cars assembled here generally sold for around $1,500, some competitors and assembly-line cars by Ford and General Motors were selling for under $1,000. That hurt the Badger Motor Car Company. Below is a Badger car in a Fourth of July parade around 1910 honoring veterans. Writing on the back of the postcard reveals that the man in the back seat at left is Conrad Koblitz (1842–1934), a Civil War veteran. (Above, courtesy of Walcott Studio.)

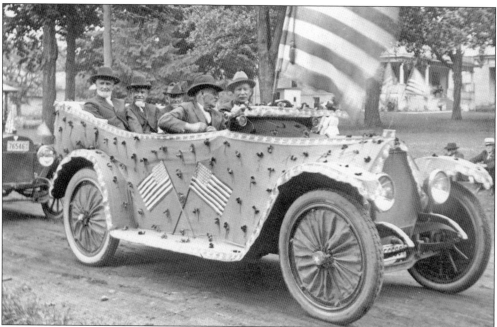

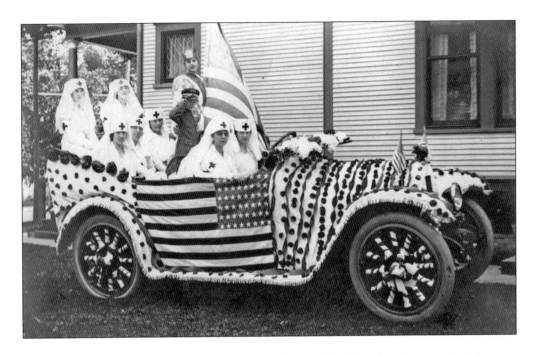

Shown here are two Badger automobiles manufactured in Columbus decorated with crepe paper pompoms with people dressed like Red Cross volunteers for the Fourth of July parade around 1910. The patriotically themed vehicle above was probably decorated in red, white, and blue. Below, it looks like the float decorators ran short on time and rather quickly put together this entry, which was probably only white with red crosses on the wheels and door. About 40 people worked in the plant assembling Badger automobiles during the company's short time of production in Columbus.

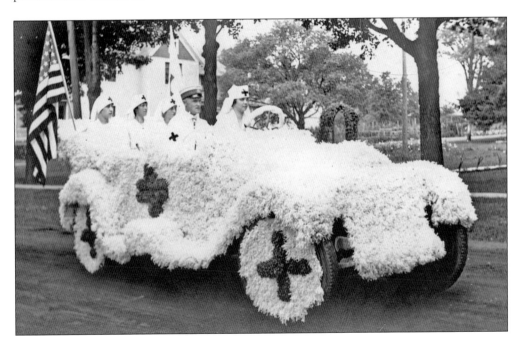

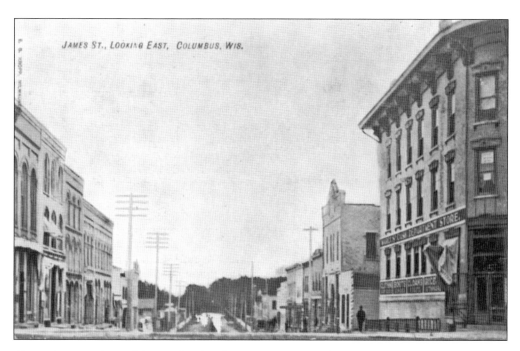

Above is a rare view of the south side of East James Street, though many postcards were found showing the stores on the north side of this block. From the corner, one can recognize the Whitney Hotel, with the Marcus Cash Department Store occupying the ground level. Proceeding down the hill, the big building with the triangular piece on top is the Kurth Saloon, at one point operated by John Gustave Heidke. Below is a much older view of Ludington Street than is shown on any other page in this book. The photographer was near the end of the business block on South Ludington Street looking north toward the four corners and beyond.

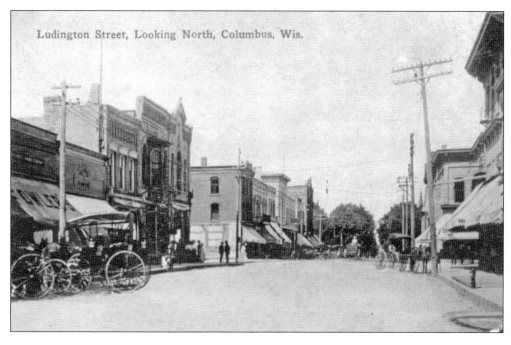

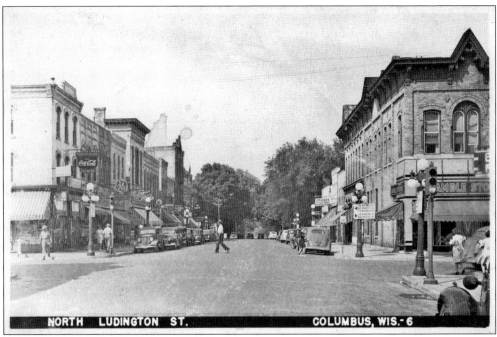

Two views of North Ludington Street from the four corners are shown here. In the c. 1940 image above, the Gamble Store is on the right corner, while Voelker's Style Shop and the Columbus Hotel are down the block. On the left, next to the Corner Drug Store (with Coca Cola sign) is the General Electric Appliance Store, a men's shoe store, Fountain Tavern, and the Tremont Hotel. Hewitt's Standard Service Station is across Mill Street. Below is the whole left block from above before the streets were bricked. From the corner are Woltersdorf Pharmacy, Weller's Sample Room, Topp's Cash Store, and Hotel Tremont, along with other stores with frayed, unreadable awnings.

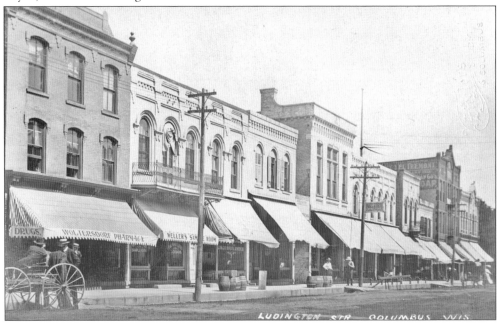

The postcard at right by Dennis Teichow features a photograph of Susan Stare's (1915–2005) painting of George Hasey's (1892–1982) 1928 Dunbar popcorn wagon. Stare's original 1981 oil painting hangs in the main corridor of city hall. Hasey was a very popular icon selling hot buttered popcorn and freshly roasted peanuts from this wagon until 1974. The contemporary card below is used as a fundraiser for maintaining the popcorn wagon. Hasey owned two wagons. He bought his first (1915) Dunbar wagon in 1918 and began selling popcorn. A gas explosion in that 1915 wagon killed his only child, Catherine, in 1946. That wagon was discovered in Illinois in 2015, refurbished, and is now in use. The 1928 wagon pictured here enjoys a few special outings when not on display in downtown Columbus. (Right, courtesy of John and Darlene Marks; below, courtesy of Walcott Studio.)

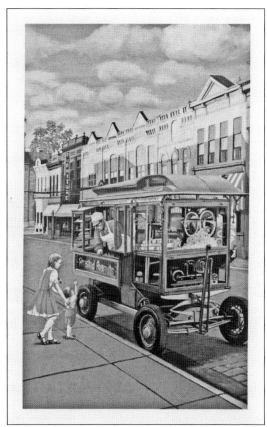

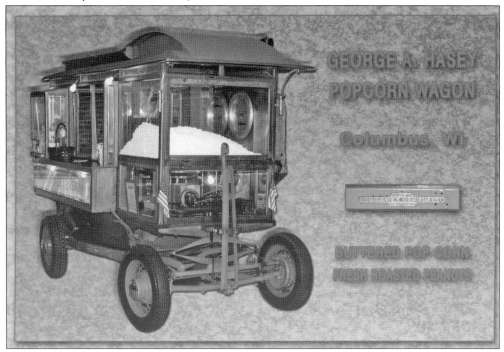

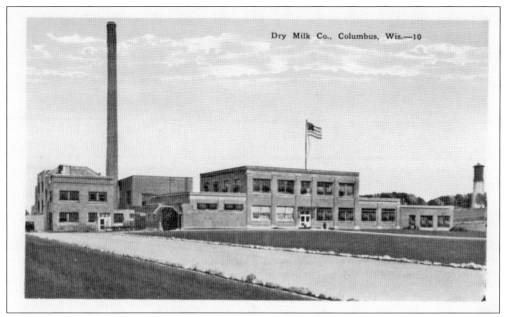

Borden's became the owner of the 1923 plant built by the New York Dry Milk Company on West James Street. Borden's operated it from the 1930s until the 1960s, manufacturing both dried milk and dried eggs. During World War II, the plant operated 24 hours a day, seven days a week producing for the military. Approximately 150 employees made Klim (powdered whole milk), ice cream mix, Biolac infant formula, and Drycol (low-fat, high-protein infant formula).

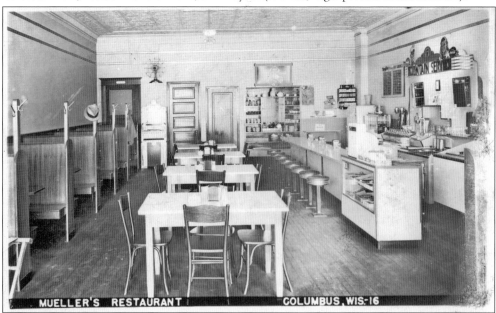

Mueller's Restaurant, adjacent to the Whitney Hotel on the east side of South Ludington Street, was a popular dining spot from 1939 into the 1960s. Friendly owners and the chef, Frederick W. "Fritz" Mueller Jr., who trained in France and Switzerland prior to joining his parents in their Columbus restaurant, were responsible. Fritz had also worked at the Pfister Hotel in Milwaukee. This is a 1947 view of the restaurant's interior. (Courtesy of John and Darlene Marks.)

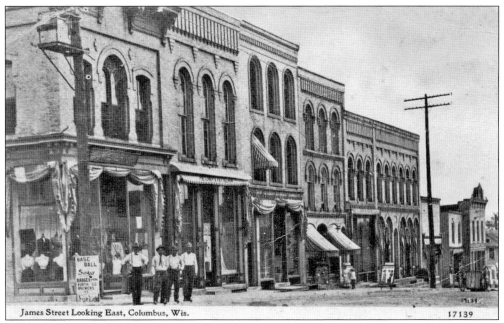

James Street Looking East, Columbus, Wis. 17539

This is a good c. 1910 view of the buildings on the north side of East James Street, beginning at the four corners and proceeding down the hill. The corner sign advertises a Sunday baseball game at Badger Park between the Kurth Co. Brewers and Fox Lake. The second store is Pietzner & Kettlehorn. Their advertisements read, "We have everything in groceries, dry goods, and notions."

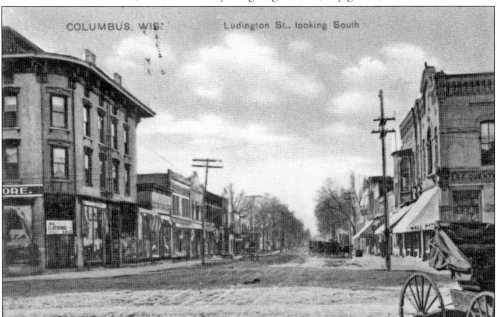

This 1909 postcard by C.P. Ziegler shows South Ludington Street from the four corners, with the Whitney Hotel on the left. Marcus Cash Store has a big clothing sale going on for 10 days only. The corner store on the right, in the Swarthout Building, was occupied by August C. Quentmeyer (1872–1931) and sold wall paint. William Koch's drugstore abuts it on Ludington Street. Quentmeyer's sons Richard and Edwin later operated the Badger Paint Store on East James Street.

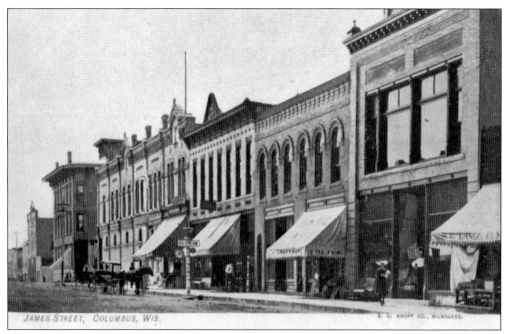

An early view of the south side of West James Street is shown above. All the stores appear to be occupied, beginning with the H.C. Lange Restaurant and Grocery at the far right. The sign that has spilled into the street reads "Ice Cream." Although not evident from this angle, Ludington Street is at left, with the Whitney Hotel and a few stores on East James Street appearing also. The c. 1945 picture below shows both busy blocks on the west side of North Ludington Street, with James Street crossing in about the middle. On the right are Fountain Tavern, Hamburger Hank's Eatery, Topp's Grocery Store, Schultz Brothers Variety Store, Nitschke's Meat Market, and the General Electric appliance dealership, among other unidentifiable stores.

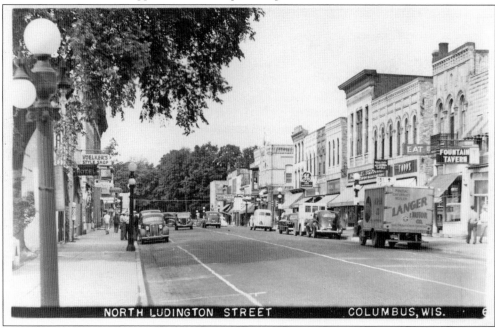

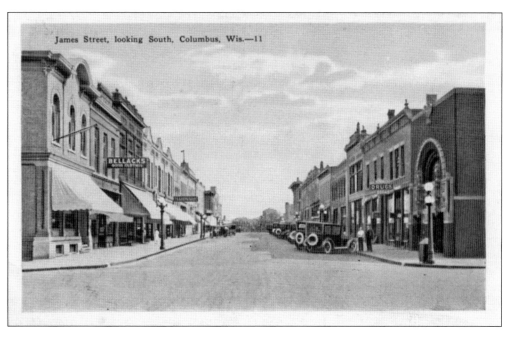

Two views of West James Street from Dickason Boulevard are shown at different periods. Vehicles are angle-parked above sometime after 1919, when the Farmers & Merchants Union Bank was built. Next to the bank is a sign that reads "Kendalls Drugs, Sodas." Signs for Bellack's Men's Clothing and a hardware store are evident in both photographs. Below is the same view, taken looking east toward the four corners, with cars parallel parked at a later date. Here, the drugstore next to the bank is Tetzlaff's. A sign closer to the four corners reads "Jeweler." From 1922 to 1951, the jewelry store was owned by James and Olga Maloney; in 1951, their son Roy and his wife, Leona, took over. Palace Clothing is also evident below on the north side of the street.

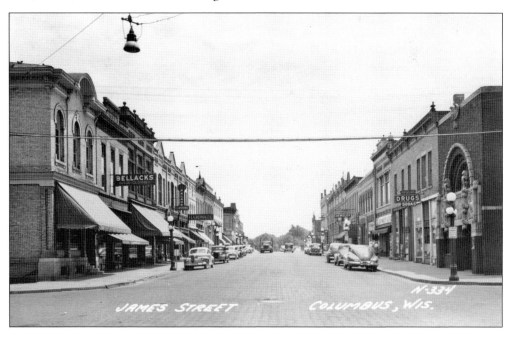

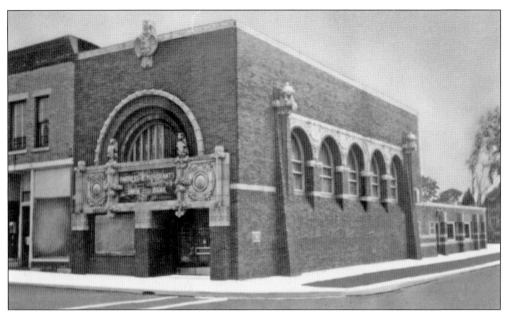

Above is the original 1919 Farmers & Merchants Union Bank, designed by noted architect Louis H. Sullivan, mentor of Frank Lloyd Wright. It was the last of Sullivan's commissions, called a "jewel box." When a drive-up was added in 1960, meticulous care was taken to match the Crawfordsville brick and elaborate green glazed terra-cotta elements. Below is the unobtrusive 1980 addition, deliberately set back slightly from the original building, with smoked-glass windows so as not to detract from the original structure. The Tetzlaff Drugstore building was demolished to make room for this addition.

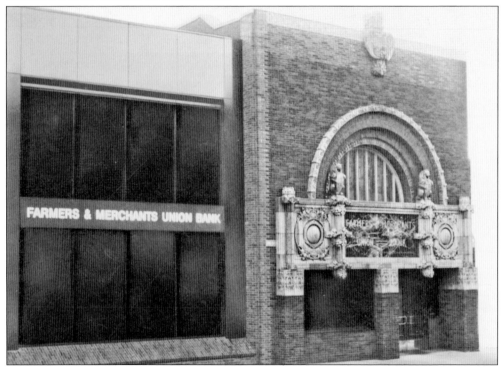

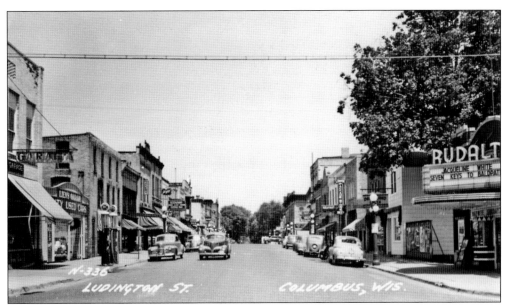

South Ludington Street is shown around 1950 looking north toward the four corners. On the left is Lien's Garage and used car lot, along with Sinclair gasoline pumps. The Rudalt Theater, named for founders Emil Rudloff (died 1936) and Henry "Crafty" Altschwager (1879–1944), was popular for inexpensive entertainment from 1917 to 1962. Many tears were shed as the building was razed for Callahan and Arnold's Law Office. Nicholas and Luvern Volpano's cozy Dairyland Lunch was next door.

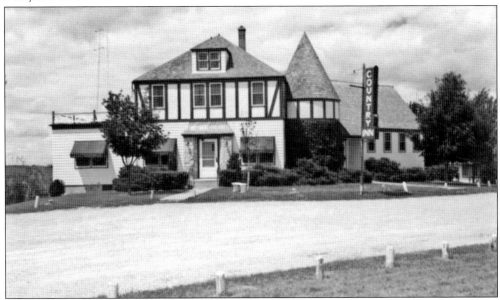

The Country Inn was a gracious supper club from the 1950s into the early 1980s three miles south of Columbus on Highway 151 at State Highway 73. Built around 1935 by Theo Voth, it initially had gambling and other illicit activities. It is believed that Chicago gangsters frequented it on trips to northern Wisconsin. By the 1950s, however, it became a family-friendly steakhouse. Under the conical roof was a round table in a comfortably padded booth with glass blocks comprising the curved window. Poker players referred to that table as "the bullpen." The building is now a residence.

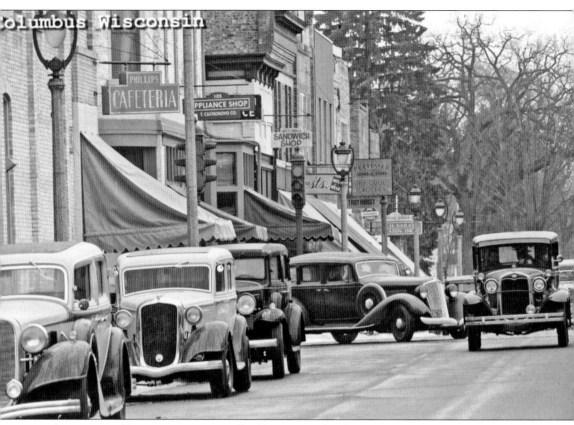

The movie *Public Enemies* was partially filmed in Columbus during March 2008. Downtown storefronts were transformed to resemble small-town America of the 1930s, when gangsters like John Dillinger were raging. The movie is an adaptation of Brian Burrough's book *Public Enemies: America's Greatest Crime Wave and the Birth of the FBI, 1933–1934* and stars Johnny Depp, Christian Bale, and Marion Cotillard. Columbus was chosen for some of the scenes because of well-kept downtown storefronts. In this scene, the vehicles are, from left to right, a 1933 Graham, 1932 Nash, 1934 Chrysler, 1934 Plymouth, 1931 Ford Model A, and 1935 Lincoln Model K. (Courtesy of Rod Melotte.)

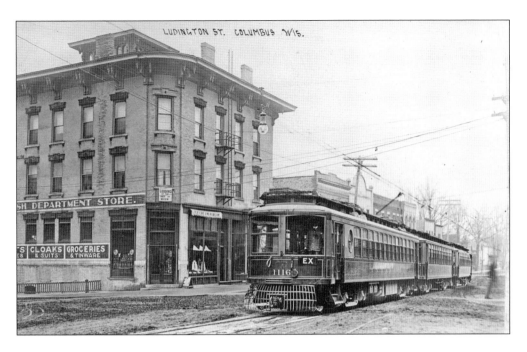

Is this a hoax? Most local historians believe it is, but based on these photographs, it is possible to make the argument that a trolley or streetcar actually did run in downtown Columbus before 1914. Above, the Whitney Hotel is home to Marcus Cash Department Store, advertising hats, shoes, cloaks, suits, groceries, and tinware. The sign above the corner door reads, "Lodging by the day or week." The store on the right of the corner is an ice cream parlor. It seems unlikely that such a large streetcar would be purchased for use in a town of less than 5,000 people. The image below shows the streetcar continuing north, past the hotel on Ludington Street.

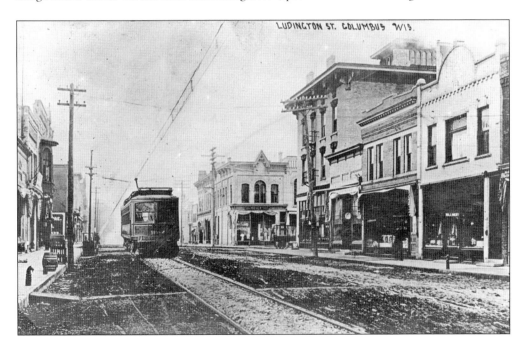

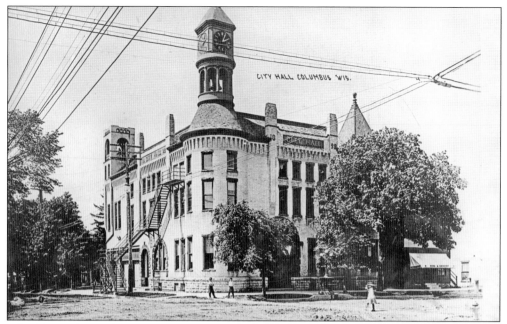

A building as beautiful and significant as city hall cannot be featured too many times in a history book. Many wires are visible above the streets; perhaps some of them were for the mysterious streetcar. On the other hand, no tracks can be seen. With the exception of the two images on the previous page, no other known photographs of downtown show streetcar tracks.

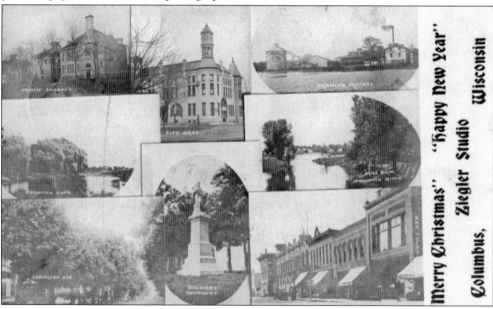

This postcard was the c. 1905 Christmas card for the C.P. Ziegler photography studio. He included eight images of Columbus along with his greeting. From left to right are (top row) public school buildings, city hall, and the canning factory; (middle row) a scene on the Crawfish River and the mill pond with its dam; (bottom row) a residential scene on Ludington Street, the Soldier's Monument, and stores on the south side of West James Street. In the small available writing space, Ziegler's message is " 'Merry Christmas' 'Happy New Year' Ziegler Studio, Columbus, Wisconsin."

Four

CRAWFISH RIVER

The 80-mile-long Crawfish River rises in Columbia County and meanders through Columbus and parts of Dodge County before heading south to join with the Rock River in Jefferson; the Rock River eventually flows into the Mississippi River. The Crawfish River played a significant role in the establishment of Columbus as a settlement. Founder Maj. Elbert Dickason dammed the river in 1839 and established a lumber mill to be able to erect buildings for the early town. Later, a gristmill was located at the dam to grind local grain into flour for the settlers. In 1900, the Crawfish River was instrumental when choosing a location to build a vegetable canning factory. Today, the river is considered a recreational asset only, but in earlier times, it also provided water for sustenance, transportation, ice blocks, and clams for both food and decorative pearls. The Columbus Conservation Club stocked the river with fingerlings from the State Fish Hatchery for decades around the 1950s, but the river is no longer considered desirable for fishing. In this chapter are several Crawfish River photographs as well as pictures of the bridges that cross it in and around Columbus.

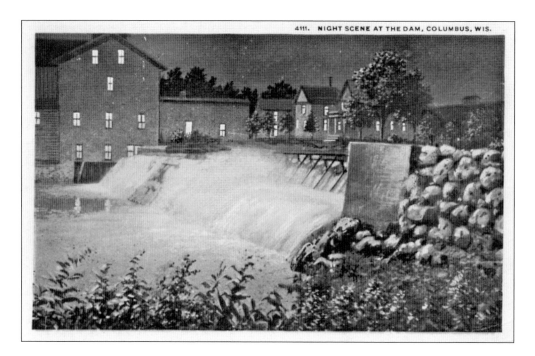

A dam was built on the Crawfish River by Columbus's founder, Maj. Elbert Dickason, in 1839–1840 to power his lumber and gristmills. It has been known as Udey Dam since 1899, when Myron G. Udey purchased it. Flour was ground at the mill until 1930. Columbus Mills operated its animal feed-grinding business at the dam until 1977. Above is a night view of the dam when it was functional. Below is a picture of water going over the spillway. Today, the dam no longer generates power but regulates the flow of the river.

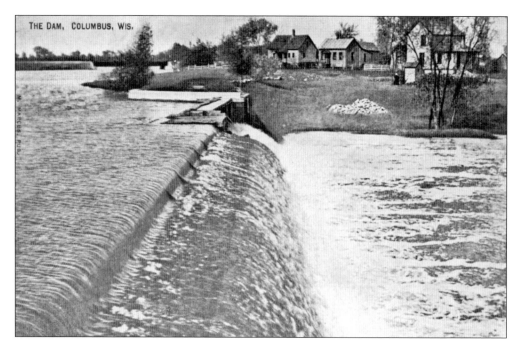

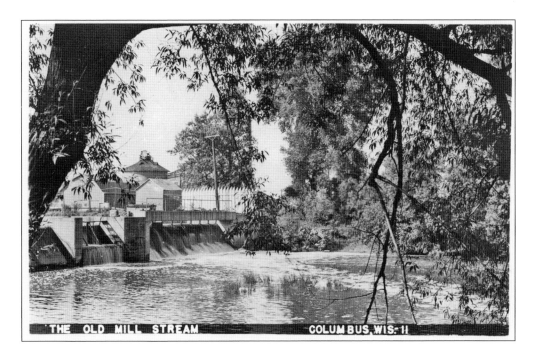

The bucolic image above shows the working dam on the Crawfish River when the milling buildings were in place. The peaceful view of the hard-working water downstream makes for a pleasant scene reminiscent of the song "Down by the Old Mill Stream." From 1839 to 1977, the mill at the dam ground grains into feed for people initially and later for livestock. Early on, the dam powered a sawmill to produce building materials. Below is another view when buildings remained at the site of the dam. Establishing the Udey Dam was a major building project.

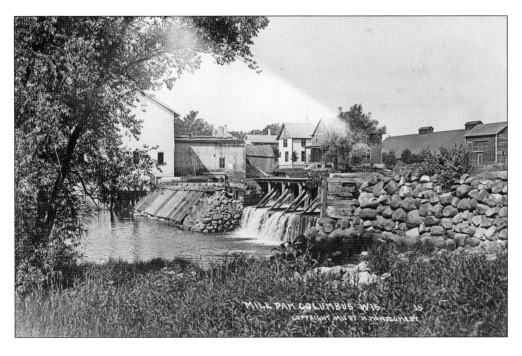

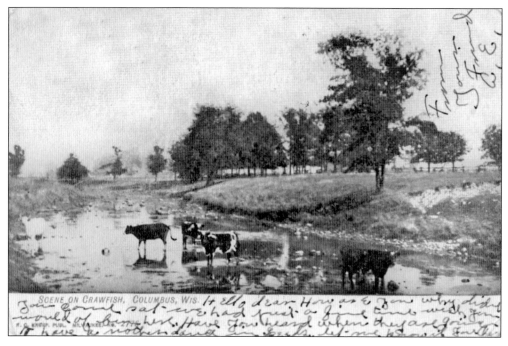

Above is an early postcard that left only a small amount of space on the front for writing a message, with the whole back for the address only. Who can even read the message? The Crawfish River is shown with cows grazing adjacent to it and wading in for a drink. Several cards show cows in the river, so this was not an unusual occurrence in the early 1900s and before. Below is a view of Plum Island on the Crawfish River. Plum Island is east of Hillside Cemetery on the northern edge of town. The main channel runs to the left in this picture.

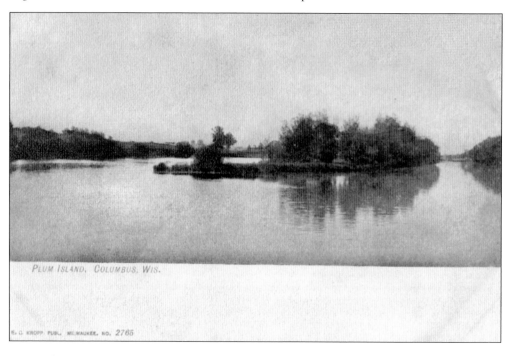

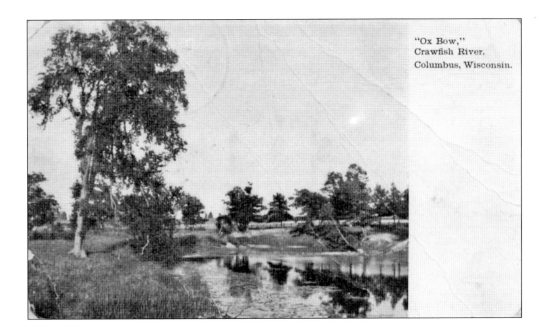

"Ox Bow,"
Crawfish River.
Columbus, Wisconsin.

Here are two postcard views of the bend in the Crawfish River, known as an oxbow. The above image appears quite peaceful, while the image below looks to be challenging for canoeing. Oxbow Road is about a mile east of town on Highway 16-60. The postcard above, sent in 1907, had space for writing both on the front and back, but the sender opted to leave the front blank. (Above, courtesy of Alice Schmidt.)

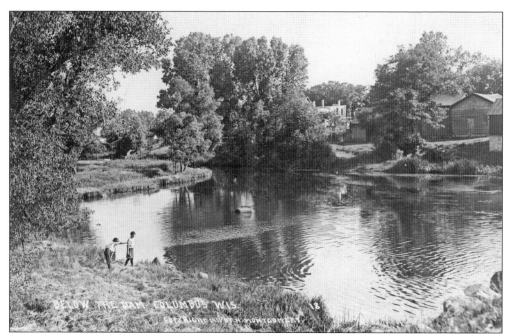

This postcard shows a restful scene below the dam on the Crawfish River. It was taken by a photographer from Hartford, Wisconsin, who copyrighted this image of two men appreciating the view. The card was mailed in 1911 with no more of a message than "Love from Helen."

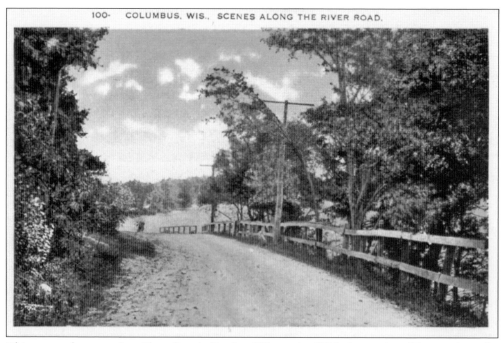

This postcard was produced by a firm in Racine, Wisconsin. With the caption, "Scenes along the River Road," it appears a bit glorified, but outside of town, along River Road, scenery almost like this view can be possible where the river widens and makes a turn. In reality, the Crawfish River in Columbus is not as expansive as it appears to be in this image.

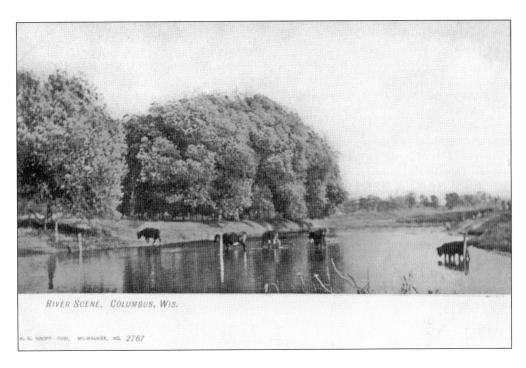

RIVER SCENE, COLUMBUS, WIS.

H. G. KROPP PUBL. MILWAUKEE. NO. 2767

Here are two images of the Crawfish River in the countryside around town. The image above is probably realistic of what could have been happening in the early 1900s. In many places north of town, the Crawfish River is shallow enough for cattle to wade across it. The postcard below was mailed in 1908. It shows an inviting, peaceful view of the river as it meanders along and provides a good afternoon's relaxation for three people.

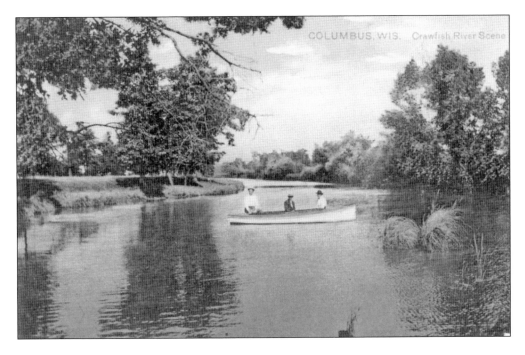

COLUMBUS, WIS. Crawfish River Scene

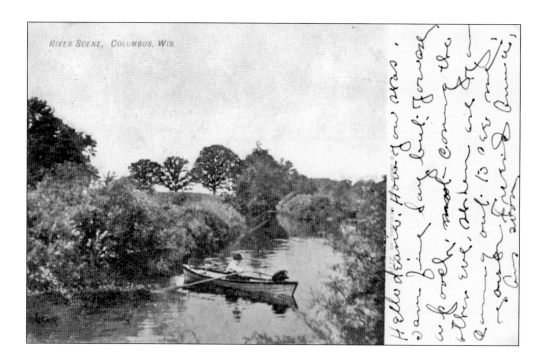

RIVER SCENE, COLUMBUS, WIS.

Above is a true-to-life image of a man peacefully canoeing on the Crawfish River. This postcard was sent in 1909, with the whole back to be used for the address. The postcard below was sent in 1944. This C.T. Art Colortone card was made by a firm in Chicago, apparently using the services of an advertising agency or public relations firm. Although it is labeled Columbus, the trees and the sandy shoreline are questionable.

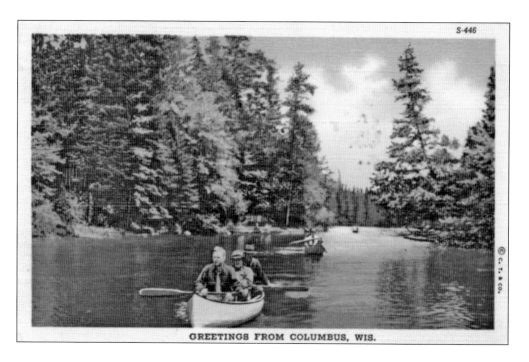

GREETINGS FROM COLUMBUS, WIS.

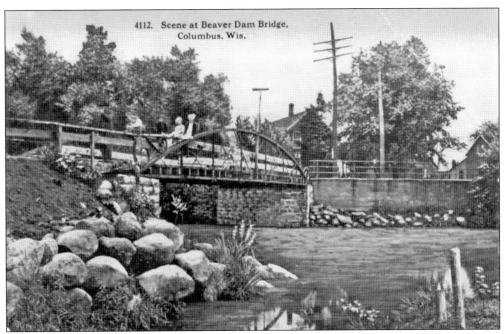

4112. Scene at Beaver Dam Bridge, Columbus, Wis.

This is a slightly glamorized version of the bridge over the Crawfish River at the northern edge of town on Highway 151 and 73 around 1900. Both vehicles and pedestrians used the same bridge, referred to as the Beaver Dam Bridge. The card reads "C.T. Photochrom" on the back. That company's skills enhanced the color of the water and highlighted the stones in ways that are not completely realistic.

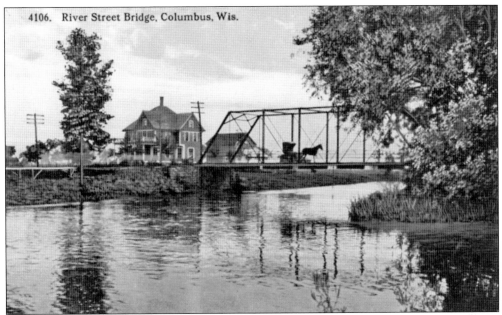

4106. River Street Bridge, Columbus, Wis.

This image, labeled "River Street Bridge," shows the c. 1890 bridge across the Crawfish River at the eastern edge of town. Its c. 1950 concrete replacement is known today as the Elba Bridge at what is now called River Road, not River Street.

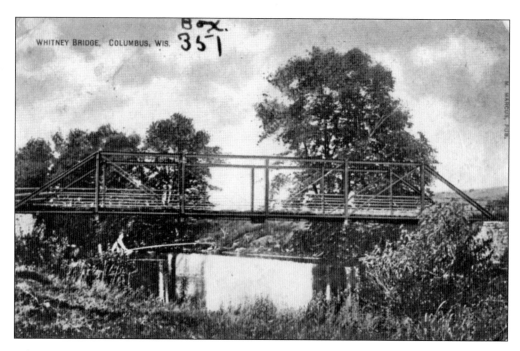

WHITNEY BRIDGE, COLUMBUS, WIS.

Whitney Bridge, over the Crawfish River about one mile north of the city limits on Old Highway 73, is shown in two versions here. Named for Henry Alonzo Whitney, an early settler, financier, and capitalist, the original bridge, likely built around 1880, is shown above. The image below, although not a postcard, shows the iron truss bridge in 1981. The floor of this 1932 replacement bridge is solid, but the metal is brown with oxidation and badly in need of maintenance.

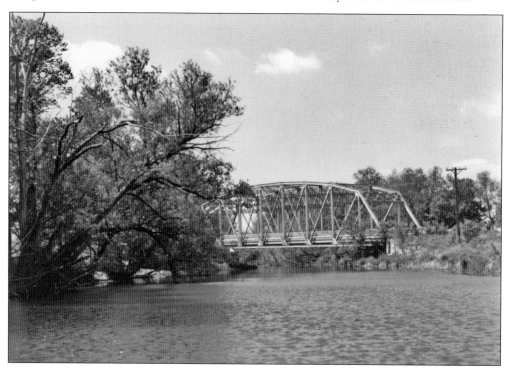

Five

FIREMAN'S PARK

Fireman's Park was established in 1916 on Highway 31, also known at the time as Madison Street. The 17 acres on the southern edge of town were swampy, due in part to an artesian well on the property. The local firemen were instrumental in helping to tile the land so it could become usable. The first building erected was the pavilion, parallel with the road. This large, two-story building with a wraparound porch on both levels has been a popular gathering spot for over 100 years because of the flexibility of its space. The local firemen also helped construct and paint the building. Both the pavilion and the 1923 Rest Haven are listed in the National Register of Historic Places. In addition to ample grassy areas, the park, which has grown to about 37 acres, is also home to the Boy Scout cabin, the state-of-the-art 2001 Aquatic Center with accompanying bathhouse, many picnic shelters, ball diamonds, concession buildings, a football field with bleachers, deer pens, extensive playground equipment, and the Veteran's Memorial Monument. Since 2013, members of the Columbus Historic Landmarks and Preservation Commission have been fundraising to keep both the pavilion and Rest Haven in good repair and usable by the community for future generations.

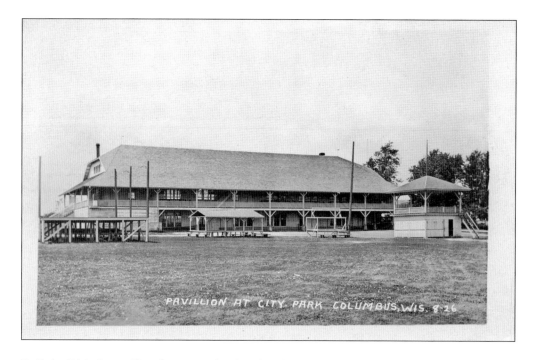

Built in 1916, the pavilion features Jerkin head gables and a wraparound veranda on both levels. The c. 1920 image above shows the bandstand (right), concession area, and bleachers in the green space, with the pavilion behind. The high school football team played its games in this area. Below is the pavilion in the background with an inviting picnic table. In the foreground are newly planted triangular annual flowerbeds. During the 1950s, flowerbeds dotted the park, but unfortunately, they were flooded during heavy rains.

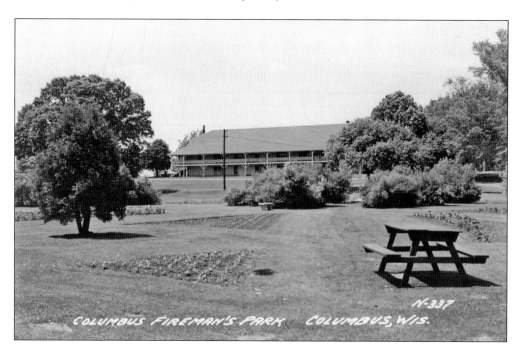

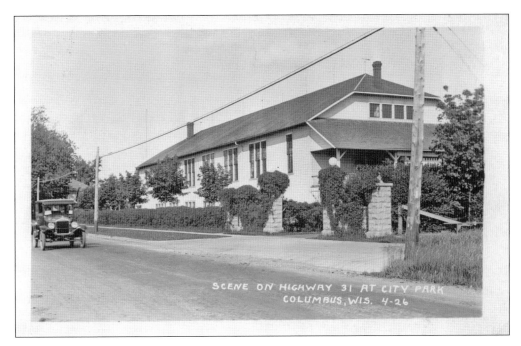

SCENE ON HIGHWAY 31 AT CITY PARK COLUMBUS, WIS. 4-26

Here are two more views of the pavilion from the south. The pavilion is the most famous building in the park and has been well used for over 100 years for dances, family gatherings, roller skating, wedding receptions, and many other activities. It was built in the style of the Alpine house barns of Europe. The image above is from around 1925, while the image below, by Rod Melotte, is a contemporary view highlighting the serenity and stability of this beautiful building. (Below, courtesy of Rod Melotte.)

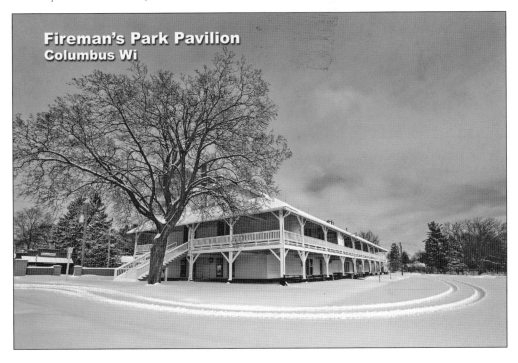

Fireman's Park Pavilion
Columbus Wi

Above is the Rest Haven in Fireman's Park, built in 1923 by James Quickenden (1855–1955), a pharmacist and son of a carpenter, as his gift to the city. This building, listed in the National Register of Historic Places, served for many years as an overnight resting spot for travelers complete with restroom facilities and a kitchen. A car, perhaps from the 1940s, is shown on the circular drive that connects the Rest Haven with the pavilion. Below, the Rest Haven peeks through the trees when the flowerbeds are in bloom. Notice how close the flowerbeds are to the stream, which could become errant.

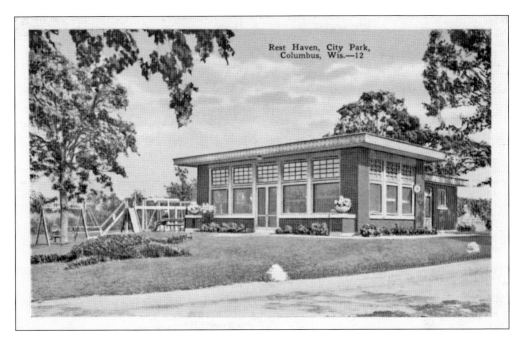

Above is a good view of the Rest Haven, which has traditionally had playground equipment near it. The building was designed by the Milwaukee architectural firm of Clas, Sheppard, and Clas and cost approximately $10,000. Today it is used for a summer enrichment program for children, family gatherings, and fundraising cookouts associated with the Fourth of July. Below is the Chadbourn Children's Memorial Building, built in 1928 as a bathhouse to accompany the new swimming pool that had just been dedicated. It was donated by banker Fredrick A. Chadbourn to honor his wife, Elizabeth. Unfortunately, arsonists destroyed the building in 1984, but the stone fireplace was incorporated into a picnic shelter. (Below, courtesy of Alice Schmidt.)

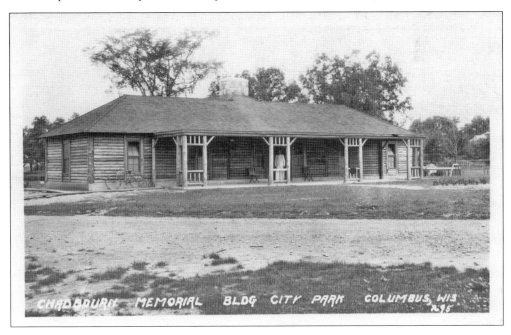

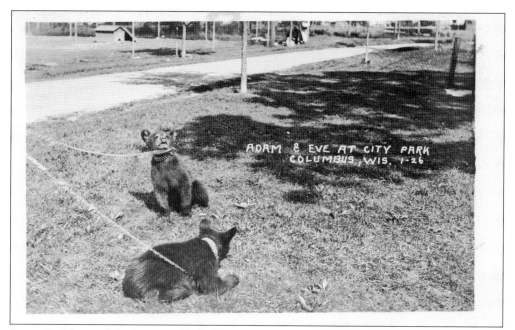

Soon after Fireman's Park was established in 1916, Dr. Bryon Meacher (a founder of the Columbus hospital) decided it should include a mini-zoo. He donated the first animals—a pair of orphaned deer—and Albert. M. Bellack, a clothier, built a pen for them. Before long, raccoons, pheasants, rabbits, and badgers were added, along with a pair of bear cubs named Adam and Eve.

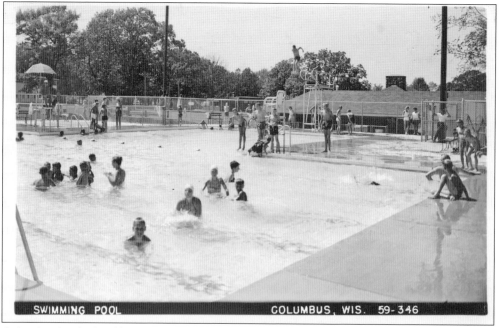

Columbus has had public swimming facilities since 1928, when "the old swimming hole" was provided by the American Legion. It was replaced in 1958 by the concrete pool shown here, a welcome recreation facility. The Chadbourn Children's Memorial Building, which served as the bathhouse, is also shown. This postcard was sent in 1960, when it cost 3¢ to mail it.

Six

MONUMENTS, SIGNS, TRAINS, AND PUBLIC SPACES

This chapter covers the other entities that are public features but were not included within the previous pages. Since Columbus is one of a few stops in Wisconsin along the Amtrak route between Chicago and Minneapolis, with one train going in each direction daily, the train is indeed significant for local residents. But it was much more important during the time frame of the majority of these postcards than it is currently. Several passenger trains used to run through Columbus daily. More significant than the passenger traffic is the number of freight trains that utilize the tracks through town around the clock. Five pages have been devoted to postcards about the trains, depot, and viaduct. Two views have been included of the Chapel Street Water Tower, no longer in service but a vital player in Columbus history. Utilizing the buildings of the former canning factory, the Columbus Antique Mall and Christopher Columbus Museum is the largest antique mall in Wisconsin. Two over-sized historical postcards that can only be purchased there are included herein. Like other chapters of this book, a few postcards of Fourth of July parade entries are sprinkled in. Celebrating the Fourth of July has been an important part of Columbus history dating to the earliest years after its founding, with only a few years in which large celebrations have not been held.

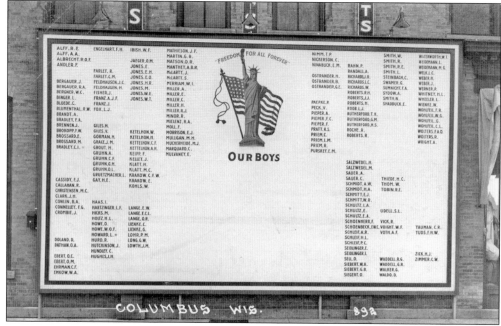

Patriotism ran high during World War I. This sign hung outside on a downtown store listing the names of local men serving in the war. Above the Statue of Liberty and American flag, it reads "Freedom For All Forever." In a newspaper picture of this sign, pictures of servicemen in uniform were included in the blank space at the bottom, perhaps on a rotating basis.

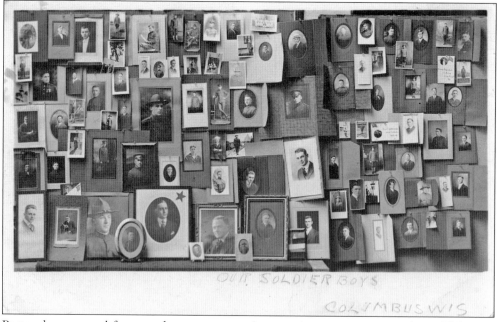

Postcards were used for several purposes as an inexpensive way to communicate. This is an example of a postcard rallying patriotism during World War I. Here, a downtown Columbus store window honors "our soldier boys" who were serving. A few pictures have a star on them, perhaps indicating the death of that soldier.

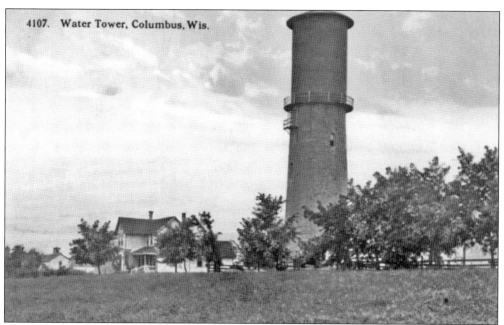

4107. Water Tower, Columbus, Wis.

Shown here are two views of the Chapel Street Water Tower, built in 1896 when the city water mains and fire hydrant systems were installed. The circular 60-foot tower sits atop an 80-foot brick base. At right is a photographic postcard by Dennis Teichow, who captured a somewhat eerie image of the water tower during a lunar eclipse. This tower remained in service until 1971, when a new water tower was erected on Tower Drive.

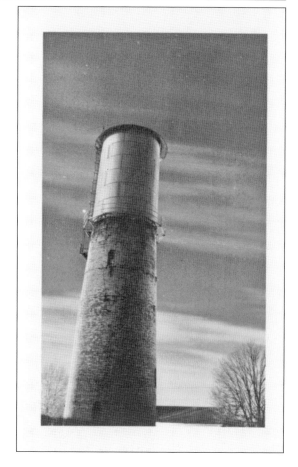

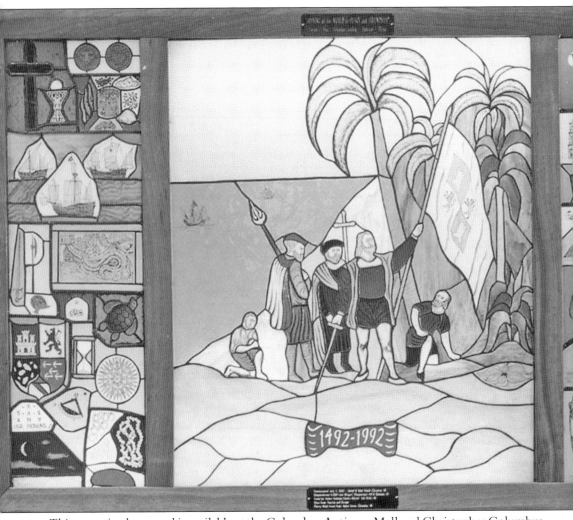

This over-sized postcard is available at the Columbus Antiques Mall and Christopher Columbus Museum. At left, the stained-glass hanging by James Weigert of Oshkosh, Wisconsin, commemorates 500 years since Christopher Columbus landed in the New World. Commissioned by mall owners Daniel and Rose Amato, it is titled *Joining of the World in Peace and Friendship, in this Age of Discovery*. Encircling the main picture are famous icons of Europe, Asia, America, and Africa, with Old

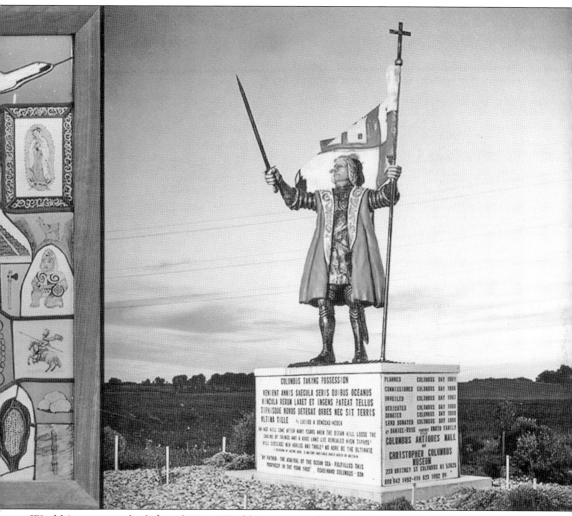

World images on the left and New World images on the right. The life-size fiberglass replica by David W. Oswald of Sparta, Wisconsin, of the Christopher Columbus statue from the 1893 Chicago World's Colombian Exposition is also shown and is called *Columbus Invoking a Heavenly Blessing on the Newfound Land*. The Amatos donated this statue and dedicated it to Columbus residents. (Courtesy of Walcott Studio.)

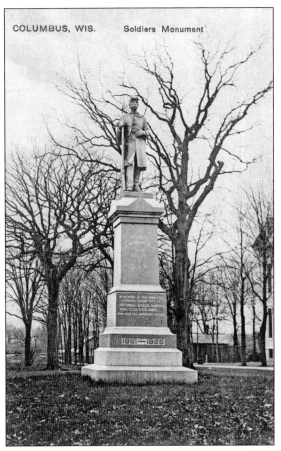

COLUMBUS, WIS. Soldiers Monument

1861 — 1865

Two views of the Soldier's Monument are shown. At left is the original soldier on the boulevard in front of the public schools. Below is the current monument in front of the library. The monument was built in 1895 and was funded by the Frank A. Haskell Post No. 146 of the Grand Army of the Republic, an organization of Union Civil War veterans. It honors area men left behind in unmarked graves in the South after the war. The foundation contains a hermetically sealed copper box naming 131 subscribers, while the names of fallen soldiers are inscribed around the base of the monument. Early on, the armodite stone soldier was vandalized. He was replaced by one of chocolate-colored copper and moved to the boulevard near city hall. Notice that the soldier's stance is slightly different in these two statues. A star-shaped planting in front of the monument is a longstanding summer tradition.

G. A. R. Memorial, Corner Broadway and James, Columbus, Wis.—4

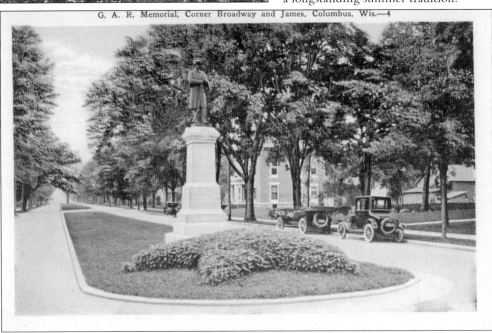

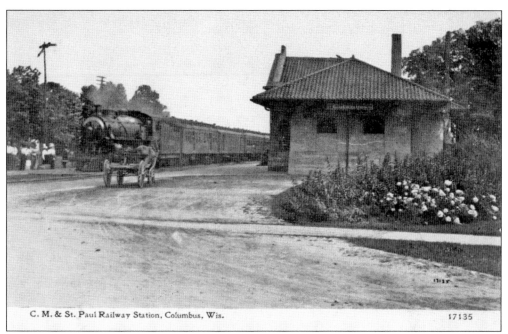

C. M. & St. Paul Railway Station, Columbus, Wis. 17135

The first train in town, the Milwaukee & Watertown Railroad, came to Columbus in 1857, stopping on Water Street where a turntable redirected the engine. In 1864, the tracks were moved to their current location and the railroad was renamed the Chicago, Milwaukee, St. Paul & Pacific Railroad. Above is the 1906 Craftsman-style freight and passenger depot. Today, the tracks are owned by the Canadian & Pacific Railroad, with Columbus as a stop for the Amtrak *Empire Builder* between Chicago and Minneapolis. Below is a better view of the same depot. The original 1871 passenger and freight depot is the smaller, light colored building adjacent to the tracks on the right.

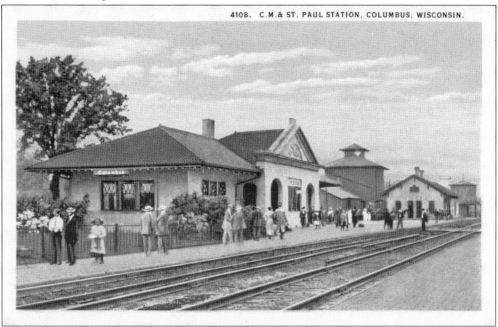

4108. C.M.& ST. PAUL STATION, COLUMBUS, WISCONSIN.

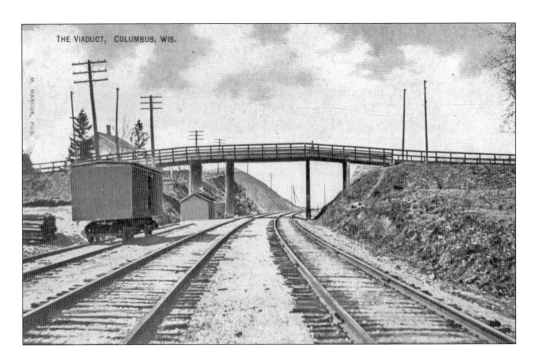

THE VIADUCT, COLUMBUS, WIS.

In 1899, a wooden viaduct for vehicles and pedestrians was built over the railroad tracks on North Lewis Street (State Highway 73), shown above. In order to accomplish that, the tracks had to be lowered slightly to accommodate the height of the trains. This wooden structure was replaced in 2002 by one made of concrete. Below is a view from the viaduct looking north toward the cemetery and water tower, with a house barely visible through the trees on the left. The Catholic church steeple is obscured by trees on the right.

View from R. R. Viaduct, Columbus, Wis.

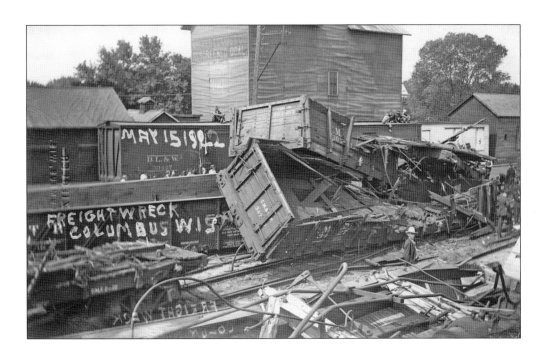

There are many postcards of the freight train wreck in Columbus on Monday afternoon, May 15, 1922. Five images are included here. Interestingly, the *Columbus Democrat* carried no pictures of this accident. An eastbound freight of the LaCrosse division of the Milwaukee Road crashed into a local freight that was switching tracks in the Columbus railroad yard. Fifteen freight cars were tossed around and crumpled as shown here. Below, the water tower and St. Jerome's Catholic Church steeple are visible on the horizon.

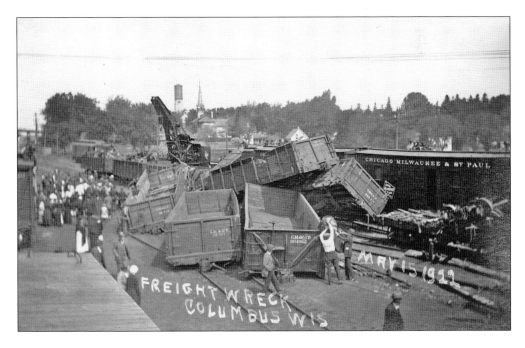

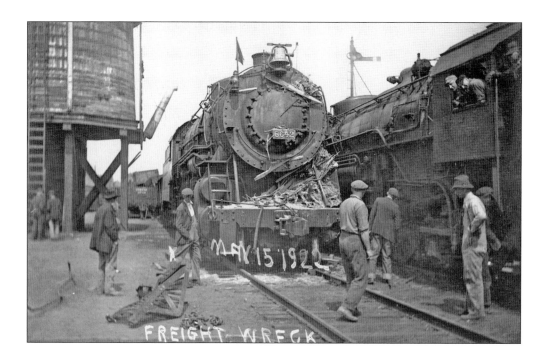

Above is the steam engine that apparently rammed the other train. In the yard at the left is the tank where the engines took on water so they could generate steam. Below is another view of some of the wreckage. According to the *Columbus Democrat*, once the cleanup crew arrived from Milwaukee, it only took 12 hours to clear the tracks. Several workmen were injured in the accident as they jumped from the train, but none seriously, and no one was killed.

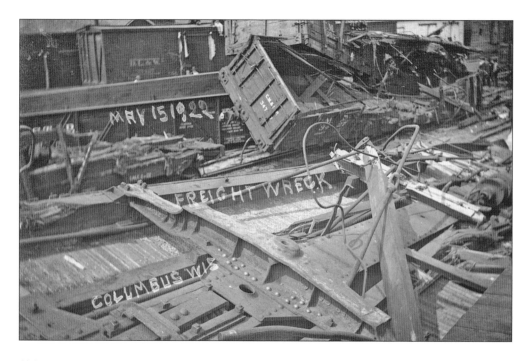

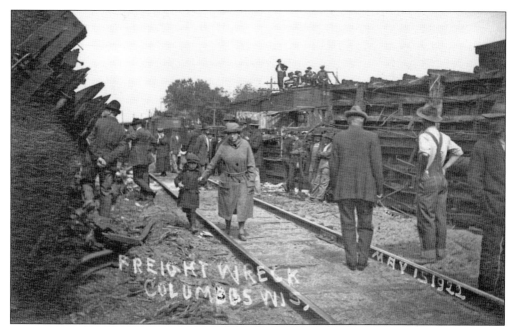

Bewildered townspeople look over the wreckage. Some have climbed onto the top of a railcar to get a better view. On the left, it appears that people are climbing onto spots where they probably should not be. An accident such as this was truly a big occasion for Columbus. Smaller accidents involving passenger trains occurred near Columbus in 1926 and again in 1928.

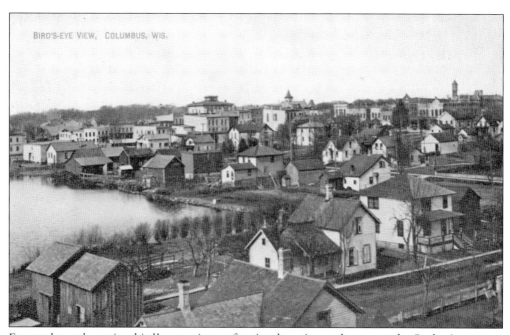

For readers who enjoy bird's-eye views of a city, here is another example. Such views were popular subjects of early postcards. Here, Columbus has been photographed near the mill pond with the Whitney Hotel, Methodist church steeple, and city hall clock tower visible, along with several homes and storage facilities.

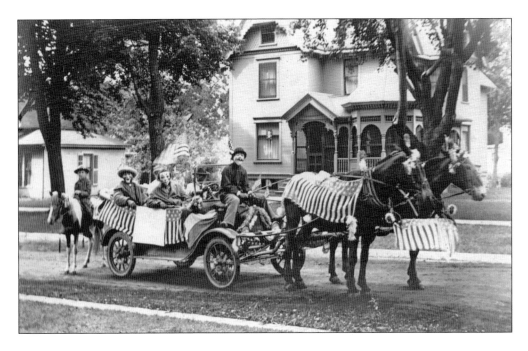

Here are examples of a special occasion used as the subject for postcards. Above, a horse-drawn Fourth of July parade entry around 1910 travels the parade route through the residential neighborhoods in the western part of the city on as-yet unpaved streets. Below is likely a Badger automobile decorated for the parade. Women and children are riding in the car with a caption that reads "Save Babies." It looks like the car has been draped with sheets and decorated with artificial flowers and American flags.

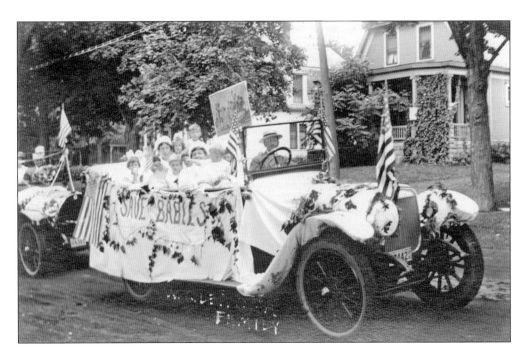

This oversized postcard is available at the Columbus Antiques Mall and Christopher Columbus Museum. Two vertical images are joined by text. Both pieces of statuary pictured are on display in the museum. The image above was purchased by Dan Amato in 2005 in commemoration of the death of Christopher Columbus and stands 21 inches tall. Made in Italy, it is titled *Christopher Columbus Landing on the Shores of San Salvador, Dawn of October 12, 1492*. The statue below, 14 inches high and titled *Watch on the* Santa Maria, is by John Rogers and depicts the three captains of the *Pinta, Niña,* and *Santa Maria.* (Courtesy of O'Brion Photography.)

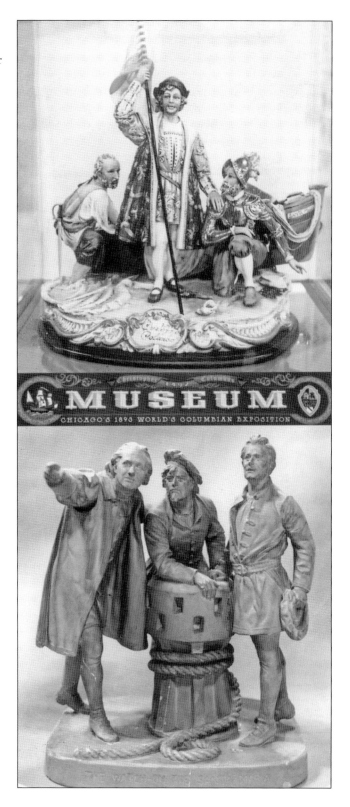

This sign is located on North Ludington Street at Middleton Street on the edge of Meister Park. It was intended to attract visitors who entered Columbus from the north on Highway 73. The postcard, by O'Brion Photography, shows the beautiful sign with vivid colors that invited visitors to explore Columbus when the sign was new. Unfortunately, the sign has not been maintained, and now the whole thing looks like it was made of weathered wood. The intention was good when the sign went up. (Courtesy of John and Darlene Marks.)

This "Celebrate Columbus" sign, erected in 2011, is at the western entry into town on Highways 16-60. Inspired by city officials, it features the city hall clock tower and Columbus as Red Bud City. It further recognizes Columbus as an energy sustainability leader. Cement block pillars support it, while solar panels provided by Wisconsin Public Power Inc. Energy and Columbus Water & Light keep it lit at night. (Courtesy of Walcott Studio.)

Seven

CANNING FACTORY

The Columbus Canning Company was launched in 1900 and for the next 77 years was a major factor in the viability of Columbus. It was located on the mill pond near the Udey Dam, where the Crawfish River conveniently provided a source of needed water. Initially, the plant canned peas and, for a short time, tomatoes. But peas and corn, both whole kernel and cream style, were the major vegetables canned here. Within a few years, the Columbus Canning Company became the largest producer of canned peas in the world in a factory that received awards for its design. In 1929, the name changed to Columbus Foods Corporation. By the time of World War II, the plant was producing large quantities for the war effort, with the Columbus plant receiving an award in 1944 for its quantity and quality of production. Migrant Mexican families and German prisoners of war were brought in to work in the factory, living in makeshift quarters on the factory campus. The canning factory also spawned many local businesses that were needed for its operation, including metal fabrication, fuel delivery, and waste management. The factory was a very good source of jobs for young people, especially college students and others seeking part-time employment. In 1945, the Columbus plant was one of five canning factories to merge with Stokely Van Camp, and the plant here produced beans in tomato sauce (pork and beans) as well as canned pumpkin, peas, and corn. The plant closed in 1977 as frozen vegetables were gaining favor over canned ones.

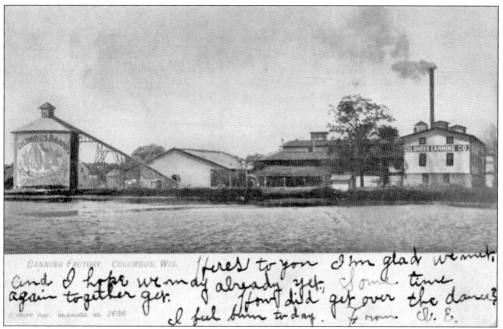

Many postcards are available of the campus of Columbus Canning Company, started in 1900. Above is a view from across the mill pond early in its history. The postcard was sent in 1907. Below is an early picture of the office staff of Columbus Canning Company. The women have been positively identified, and the men's identities are likely correct. From left to right are Harmie Welk; Frederick A. Stare, the plant superintendent who was also involved with bookkeeping; Eva Blakeslee; and Albert M. Bellack. With his brother Bernard, Bellack was a clothier, but he also held several different positions in the canning factory in a career that lasted more than 30 years, serving as plant manager and corporate secretary as two examples.

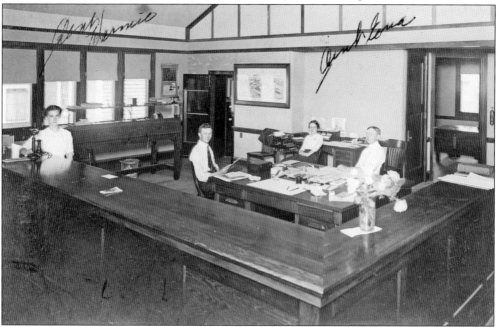

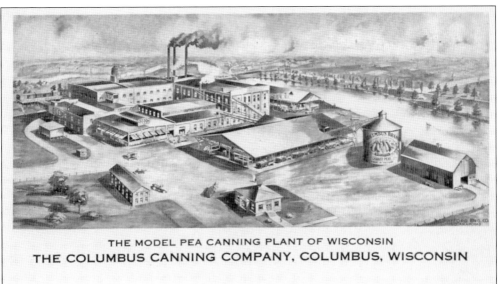

THE MODEL PEA CANNING PLANT OF WISCONSIN
THE COLUMBUS CANNING COMPANY, COLUMBUS, WISCONSIN

Two exterior views of the campus of Columbus Canning Company are shown here. The Columbus Canning Company began in 1900 and quickly grew into the largest pea canning plant in the world. Above, it is identified as "The Model Pea Canning Plant of Wisconsin." The c. 1915 image below shows the growth in the size of the operation from the earlier picture on the preceding page. In 1929, the name changed to Columbus Foods Corporation to align with interstate trade laws in the canning industry.

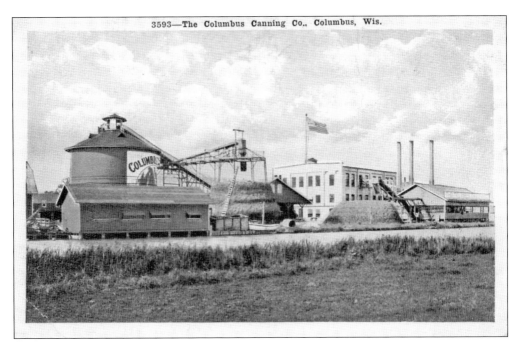

3593—The Columbus Canning Co., Columbus, Wis.

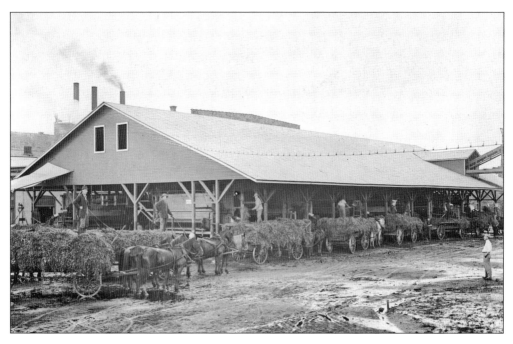

Two photographs of pea viners are shown here. Above is the older shed, in which eight viners operated. Several wagonloads of pea vines have come to the plant pulled by horses. As the peapods were stripped from the vines and peas removed from their shells by the viners, large quantities of liquid were generated. From the viners, the peas went by conveyor belt into the plant for processing. The image below, from after 1911, shows the new viner shed that replaced the one above. In later years, viners were established on several area farms, and the shelled peas were hauled into the plant for processing.

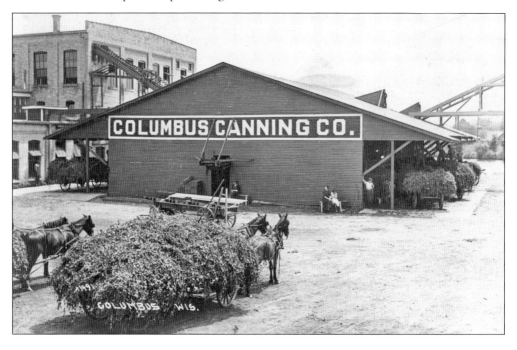

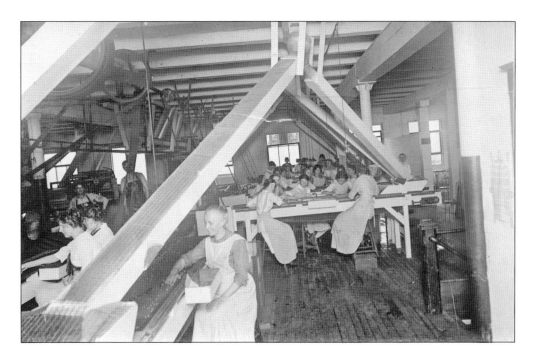

Above is the picking room, where women and girls sorted through the peas as they passed on a conveyor belt. The women removed all sorts of impurities that managed to come along with the shelled peas—thistles, leaves, pods, sticks, stones, and portions of snakes and animals, among other things. Below is the processing room, where 21 retorts (large vessels) could cook the food product at the rate of 1,000 cans per minute. On the right in the back is Reese Roberts, the fabricator of the retorts, with Bill Emkow working in the front.

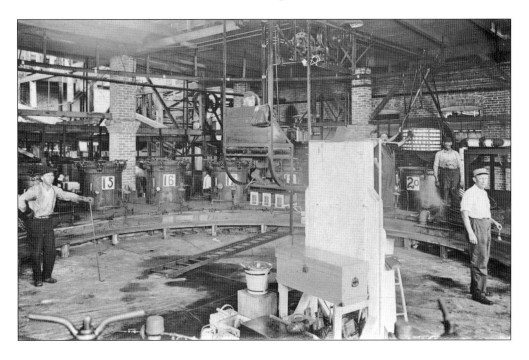

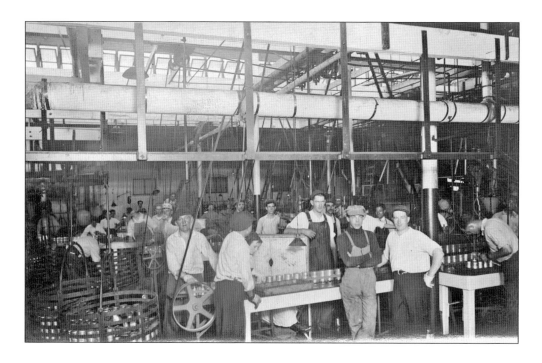

Above is the line room, where five conveyor belts moved the filled cans along in preparation for packing into cases. The lines could move 505 cans per minute. The plant in Columbus packed primarily peas and corn, both whole kernel and cream style. Below are the workers in the casing room, where the cans were packed into cases. The message on the back of this postcard reads, "My grandfather, Frank August Welk," but his position is not identified.

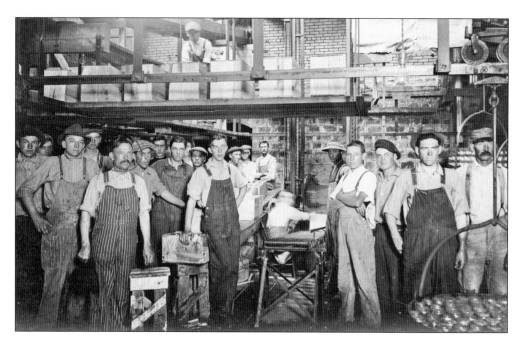

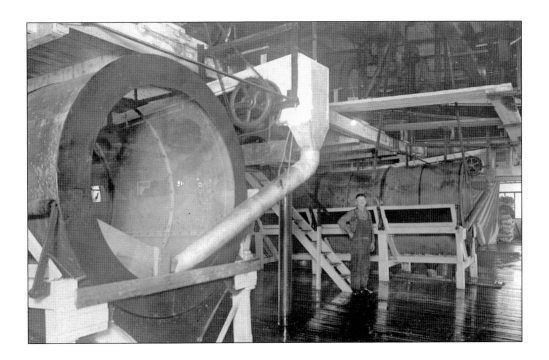

Two more views show the inside of the canning factory around 1915. Above is the grading room, where peas were separated into sizes, or grades, before the cans were filled. Below appears to be the area where the filled cans were moved from one spot to another, traveling overhead. Two men are watching to be sure all the cans keep moving properly.

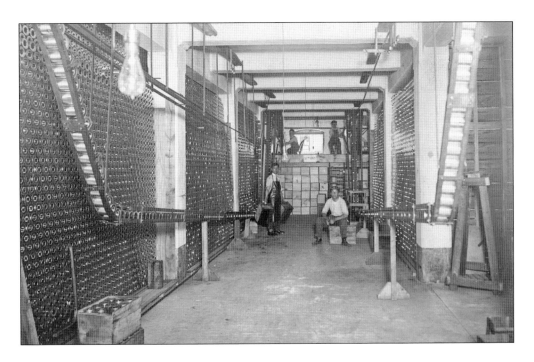

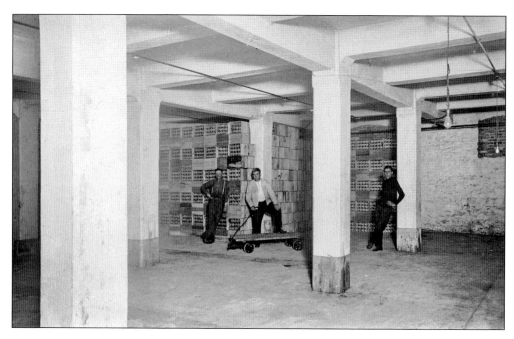

The c. 1913 image above shows the warehouse with three unidentified workers. Packed 24 cans per case, the warehouse could store 150,000 cases at a time. As unsold Badger automobiles began to accumulate, they were stored on the third floor of this warehouse, since many principals of the Badger Motor Car Company were also involved in the canning factory. The c. 1913 image below shows a group of the factory employees, probably the core of full-timers. Many young people were also hired to work on a part-time basis. Records show that in the earliest days of the factory, young people were hired to shell peas and husk corn by hand.

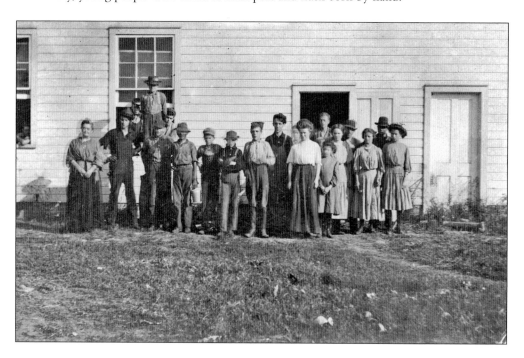

Eight

PEOPLE AND GROUPS OF INDIVIDUALS

This chapter contains photographs of individuals and groups of people. During the early 1900s, before sophisticated methods of communication had been developed, many different subjects were chosen to be printed onto postcards. Several full-length images of well-dressed young people with pleasant countenances were found. These were likely high school graduation portraits, meant for exchanges with friends. The files also produced many more group images on postcards than are included here. Unfortunately, the purpose for these group photographs was usually not identified on the card, nor were the people identified by name, so those postcards were not included. The collection of high school yearbooks at the local library is very sporadic for the years prior to 1920. The high school staff could not produce copies of yearbooks for the early 1900s either, and they are not available at the Wisconsin State Historical Society. Nonetheless, it is interesting to notice the number of different subjects that were retained as postcards, a step above just saving them as a regular photograph.

Two postcards of goat carts were found. Above is Lester "Mike" Schmidt (1905–1977) riding in a cart pulled by a goat for the fun of it. His parents were good friends with Dr. Edward M. Poser (founder of Poser Clinic) and his wife, Adele (commonly called Hattie), owners of the goat and cart. This picture was taken across the street from the house where the Posers lived. Looking carefully today at 351 South Dickason Boulevard, the front steps shown here can be seen, and the lattice-work closely resembles what would have been in place more than 100 years ago. Below is Wesley Kopplin (1905–1991), also riding a cart pulled by a goat, but the carts have different seats. Kopplin delivered milk to his neighbors in the 400 block of West Mill Street. (Above, courtesy of Alice Schmidt.)

These postcards are examples of high school graduation pictures turned into postcards for sharing. The Columbus Historic Landmarks and Preservation Commission files contain several other full-length photographs similar to these. At right is Ernest Schultz (1892–1976), a longtime Columbus pharmacist who owned and operated the Corner Drug Store from 1930 to 1968. Below are his sisters, twins Freda Schultz (1894–1992, left) and Hilda Schultz (1894–1991, right). Always referred to as "the Schultz girls," the twins spent the majority of their lives working in Columbus and participating in community activities, making many friends along the way.

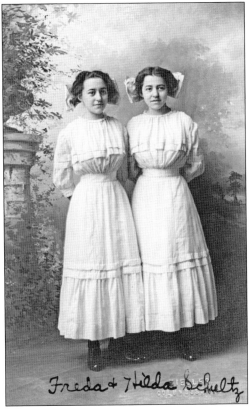

Here are the pianos in the living room of Julius Krueger's home in west Columbus. His maiden daughter Clara gave piano lessons. Gloria Obermeyer recalls playing the piano on the left while Clara played the one on the right in the 1930s. The message on this card reads "Wishing you a Merry Christmas and a Happy New Year. Clara Krueger." She apparently had several of these postcards made as her Christmas card.

This is the Columbus High School orchestra in 1912, documented by the *Omnibus* yearbook. Orchestra members are named by their section. The violins were Blaine B. Coles, Raymond Thiede, and Elmer E. Thompson; the clarinet was Max C. Klatt; the flute was Lawrence S. Howard; the piano was Allyn L. Wright; the drums were Rodney Hurd and William J. Evans; the trombone was unidentified; and the director (not shown) was Kate Gulliford.

Here is an excellent example of a postcard used for advertising. Photographer Carl P. Ziegler compiled several of his heartwarming baby and young children photographs for this postcard, then added a personal message: "Have your baby's picture taken at the Ziegler Studio." This card was mailed in 1907, when the whole back was reserved for the address, with little (but enough) writing space on the front. (Courtesy of Alice Schmidt.)

The purpose of this photograph cannot be determined. However, Ruth Sutton and Gerald Walker graduated from Columbus High School in 1914. The other names were not listed as their classmates in the *Mekon*, the Columbus High School yearbook for 1914. From left to right are (first row) Edna Weidemann, Gerald Walker, and Ruth Sutton; (second row) Eugene Brossard, Isabelle Reuter, Kenneth Jones, Charlotte Cowley, and Less Weidemann. The photograph is by J.L. Trapp.

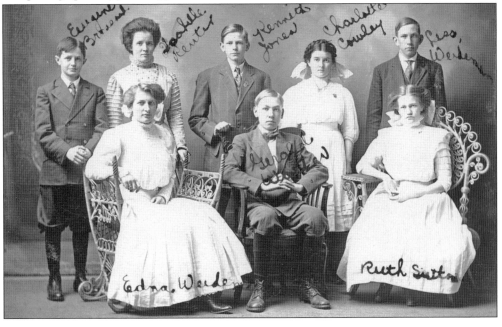

This postcard was found along with other sports materials from around 1910. This is the Columbus High School football team, but the players' names are not matched up with their photographs. William J. "Bill" Evans wrote a message on the back to his friend, Syd: "This is the great football team. The regular team was Elmer J [or T], Bob A., Herb B., Doland, Griffin, Ford, Evans, Zick, Crombie, Les [or Len] W., Bill R., Edd Jones, Skinny, Miller. The rest we had as subs. Some bunch just the same." Evans graduated from Columbus High School in 1912.

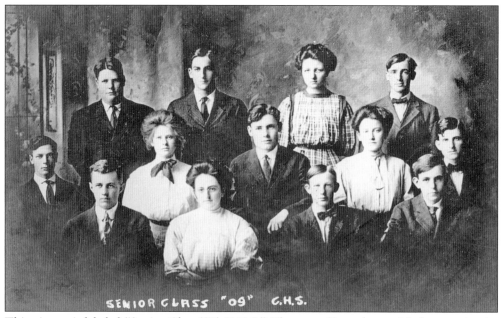

This picture is labeled "Senior Class '09' C.H.S." There are 13 graduates. Unfortunately, the high school yearbook for 1909 is not available at the library or the high school, so the people could not be identified.

Nine

WHIMSICAL, DECORATIVE, AND COMICAL

The postcards in this chapter are not historical views of Columbus, but nonetheless they are cards that circulated during the early 1900s along with the realistic images included in this book. These cards are good examples of postcards sent to strengthen a friendship and in some cases to elicit a good-natured chuckle out of the recipient. All the cards in this chapter are labeled "Columbus, Wisconsin," but whether or not they are realistic is up to the reader to decide. There are examples of cards that are artistic and beautiful—one is even embossed and three-dimensional. A few feature gold ink in an effort to make them especially appealing. Another card has lettering done in glitter and beautiful blue flowers with glitter in their centers. The last four postcards are an attempt at being comical. These are all examples of the style and type of artwork used on postcards sent during the early 1900s, during the golden age of postcards.

A Happy New Year

A photograph cannot do justice to this charming postcard, made in Germany, that was sent in 1909 as a New Year's greeting. All the elements are done in gold ink, with the square background around the clock face particularly shiny. Notice that the clock is ready to strike midnight. Around it are four-leaf clovers and horseshoes to wish the recipient good luck in the year ahead. The postcard is addressed simply to "Miss Laura Schmidt, Columbus, Wis." (Courtesy of Alice Schmidt.)

This example shows some of the artistry that went into making postcards in the early 1900s. The shaded pink flowers are embossed. The border around the verse and the border at the edge of the card are done in gold ink. The verse reads, "Well, here I am at Columbus, Wis. Enjoying its sights and cheer: Everything's great, and I'm feeling first-rate, But oh! How I wish you were here."

Well, here I am at
Columbus, Wis.
Enjoying its sights and cheer;
Everything's great, and I'm feeling
first-rate,
But oh! how I wish you were here.

This is a special example of a postcard that is far from ordinary. The writing is done in glitter, and the blue bachelor button (or cornflowers) have glitter in their centers. Printed on the top of the back is "Pestkarte—Carte postale—Post card—Cartolina postale." (Courtesy of Alice Schmidt.)

GREETINGS FROM COLUMBUS, WIS.

This card is pleasant to look at but may be only partially representative of Columbus scenery. Both apple trees and cows are commonly seen around Columbus, but it is unlikely that a cow would be allowed to graze in an orchard as large as is illustrated here. This is a good example of advertising people trying to promote Columbus by using subject matter that many people appreciate. (Courtesy of John and Darlene Marks.)

Rite a Nice Ledder to

FROM_____

COLUMBUS, WIS.

Chust so Long

This humorous card was sent from Columbus in 1913. Many immigrants from Germany settled in Columbus in the 1850s and were responsible for operating the area farms, businesses, and the Kurth Brewery empire. The artist of this postcard seems to be mocking their accents in a good-natured way.

WHEREVER this may find You
I trust it will remind You
of ONE in

You
left
behind
You

COLUMBUS, WIS.

The message on this humorous card is a bit cryptic, but apparently some people found it to be worthy of sharing with their friends. Trains were popular in Columbus in the early 1900s. They made a good subject for this postcard, which reads, "Wherever this may find you, I trust it will remind you of one in Columbus, Wis. you left behind you."

IFF YOU VILL COME TO

COLUMBUS.

VE VILL LOCK UP ALL DE COPS.

This comedic card has both a humorous message and an offbeat illustration. Knowing that many emigrants from Germany settled in Columbus, the author is surmising the writer of the text was poking a bit of fun at their manner of speaking. This card was mailed in 1913 to an address that included no more than the recipient's name and "Wilton, Wis."

OUR PLEASURE COST US BIG MONEY !!

COLUMBUS, WIS.

This comedic card shows the constable with an errant man standing before the judge. The man says, "Our pleasure cost us big money!!" It is not a message that particularly promotes Columbus, but nonetheless, the card was produced because a certain audience at the time would have seen some humor in it. (Courtesy of John and Darlene Marks.)

Discover Thousands of Local History Books
Featuring Millions of Vintage Images

Arcadia Publishing, the leading local history publisher in the United States, is committed to making history accessible and meaningful through publishing books that celebrate and preserve the heritage of America's people and places.

Find more books like this at
www.arcadiapublishing.com

Search for your hometown history, your old stomping grounds, and even your favorite sports team.